EXPEDITION
SKETCHBOOK

CYARIN

Translated To English From Dutch

This book belongs to

EXPEDITION SKETCHBOOK

CYARIN

Inspiration and Skills for Your Artistic Journey

BLUE · STAR
PRESS

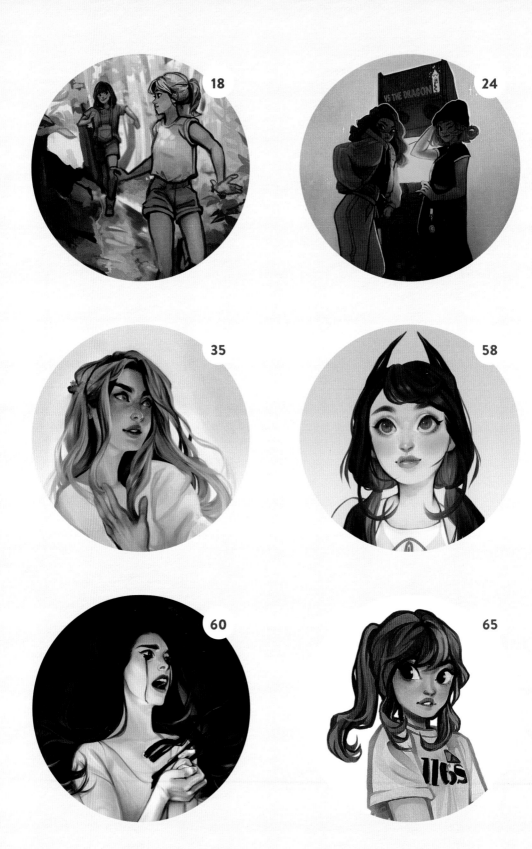

CONTENTS

This is me **13**

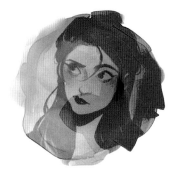

CHAPTER 1

ON DEVELOPING A PERSONAL STYLE

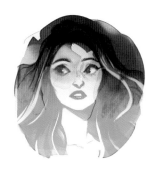

CHAPTER 2

TOOLKIT & BASICS

CONTENTS

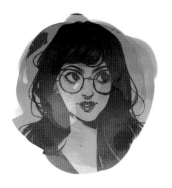 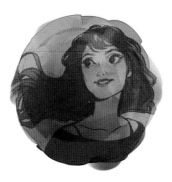

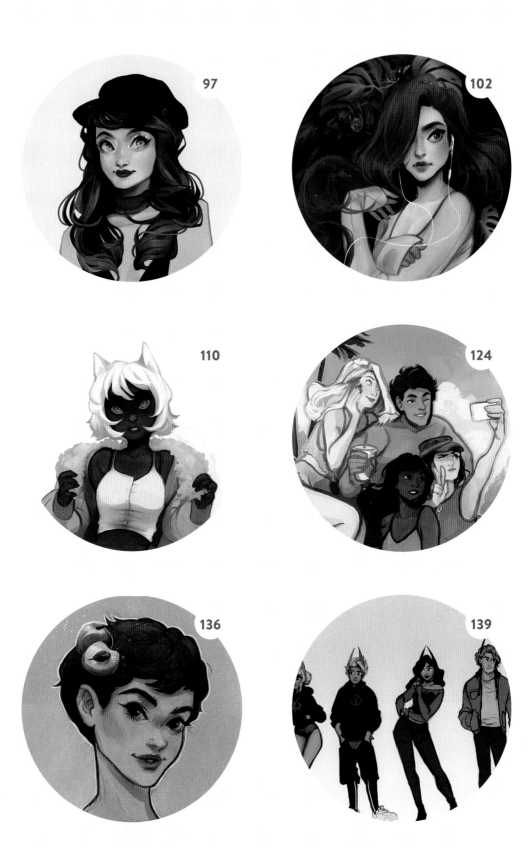

THIS IS ME

Maybe you picked up this book because you know me, Laura, or you know Cyarin (my artist name). Maybe you're just curious, but in any case, I would like to thank you. Because I often have to summarize my thoughts as an artist in short, time-sensitive answers, I wanted to write a book that gives people the answers they deserve; long and thoughtful ones. This is my personal expedition and on the way, I'll give you all the advice, tips and tricks that really helped me get to where I am today.

Professional Doodling

I'm still in the initial phase of my expedition, a voyage of discovery for myself and my work. I am an artist, illustrator, designer, or whatever you want to call it, and I kind of just fell into this field. My drawing skills are self-taught and I got my start with few resources in the professional world. I post much of my work online where I have a lot of personal friends, professional contacts, and followers. Although I sometimes doubt the value of my work (like many other artists), it's these people who remind me that all the hours I spend behind the drawing board are worth it. I will never find the right words to express my gratitude but without them, there would be no Cyarin; there would be no me.

This is NOT a How-To-Draw Book...

In this book I share my experiences with you and show you what I do for inspiration. You can do the same exercises that helped me to develop my style, in hopes to improve your own. A drawing is never finished and as a creative, you are never done learning. So, this is not a book that says how it should be done, but shows how it is possible. I hope to provide inspiration with my pieces and notes, as this book is meant to be a sneak peek into my sketchbooks. It includes notes and sketches for everyone—experienced or new to drawing, character artist, comic artist, painter of landscapes, or illustrator of animals. With this book, I want to remove the mystery that cloaks the world of artists and shine some light on my own experiences. You'll discover that we all run into the same challenges and problems,whether you draw professional-ly or not. The mountains we must constantly climb are just part of an artist's existence. Let me guide you through all of the peaks and valleys I've experienced in my journey.

Laura

two colors of blue:

cyan
+
aquamarine
=
cyarin

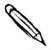

WHO ARE YOU

Draw a self-portrait. Draw it as you see yourself, not necessarily a literal representation. Think of things like body language and external characteristics. If it fits better with your character style, you can also draw yourself in a more abstract form.

This assignment comes back at the end of the book, so hang on to the drawing.

#EXPEDITIONSKETCHBOOK

Share your results of the exercises in this book.
Post your drawings with the hashtag **#expeditionsketchbook** on Instagram and tag **@cyarine**.

Cyarin/e

Two colors of blue—aquamarine and cyan—delivered my artist name, Cyarin. For my Instagram account I chose @cyarine, because the @cyarin handle was already taken.

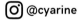 **@cyarine**

'Nothing is more unique than your own style, you just have it!'

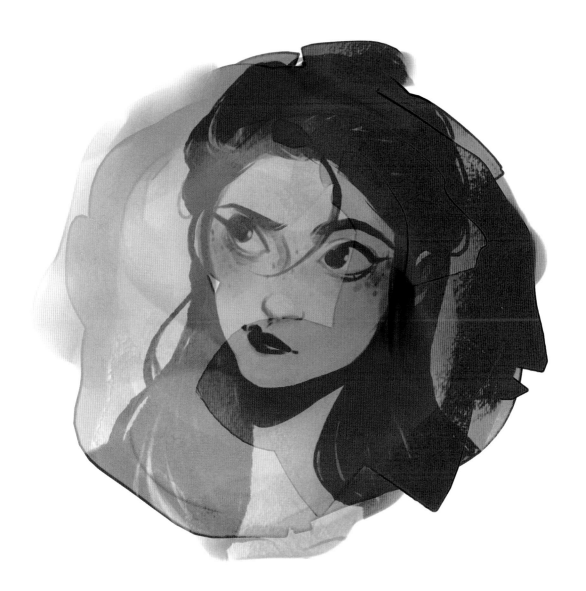

CHAPTER 1

ON DEVELOPING A PERSONAL STYLE

FOREST

For this drawing, I used a positive memory as a starting point—something from everyday life in my youth. We lived next to a forest and my younger sister and I spent a lot of time there. Experiences from your own life are often a great source of inspiration, and it's easier to draw what inspires you.

I used different photos as reference material for the trees and forest. I don't usually draw many backgrounds, but I wanted to challenge myself. The development of a background is one challenge for me. With most characters, I draw exactly what I want. The rendering—adding of detail, and shading—adjusting the brightness and the contrast—is not a problem at all. That is my specialty. The struggle with this drawing is the rendering of the background. I finally succeeded but it took a long time. In this case, I found it difficult to determine how much effect I wanted to use, and how much I wanted to render.

Looking back, I realized that a lot of my frustration stemmed from the fact that I wanted to achieve the same quality as my figures. When I try something new, I want to do it as well as the things that I have been making for much longer. This is an unrealistic expectation that stems from my perfectionism. Recognizing these unrealistic expectations helps me to stop worrying and get back to work. Our sketch tools are not magic wands that can create anything once we learn how to properly wield them. Every different image in every different medium is a new form of art.

In this drawing, I used a rough brush and then carefully worked out the details, intentionally leaving some parts with an unfinished look. Compare it to a photographer who chooses what she brings into sharp focus: focus your lens on what is important.

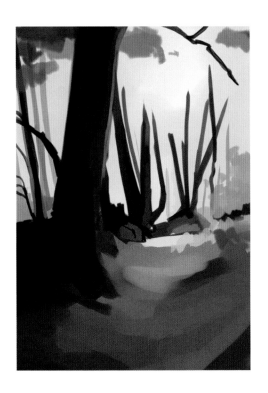

PROCESS

Here, I show my step-by-step process of the Forest drawing. With every sketch, it will look like just a slight change, but if you look closely, you will see the different design steps.

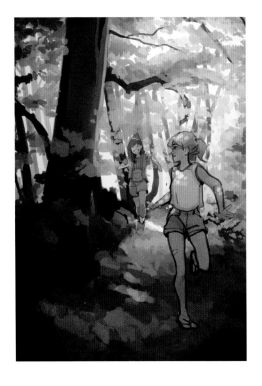

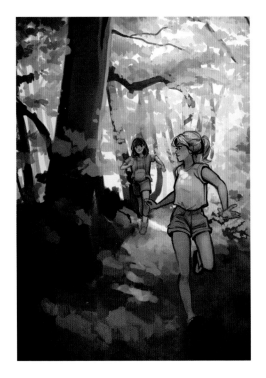

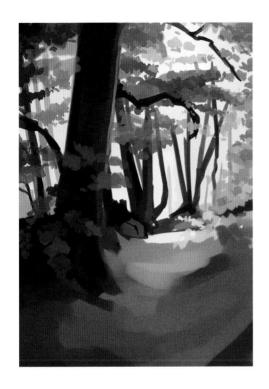
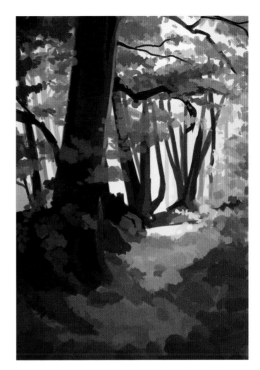
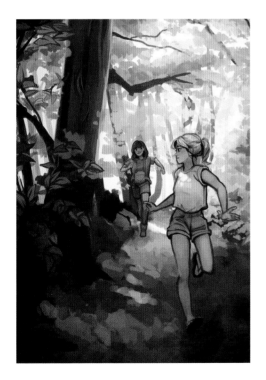
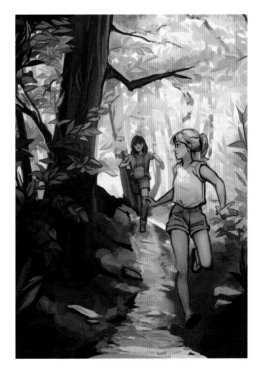

fashion/design

nostalgic cartoons

fantasy movies/
books

Lord of the Rings

Inkheart - Cornelia
Funke

W.I.T.C.H.

personal relationships

LGBTQ+ people
and personal
experience

beauty/makeup

hair (styling)

bloggers, fashion icons

plants

sci-fi

occult/horror

urban legends

mythology

Animation
Disney, Ghibli
Pixar

Satoshi-Kon

Paintings

games

Women ♥

vaporwave

a e s t h e t i c

Inspiration

For me, inspiration can be found everywhere. Everything fascinates me in daily life: food, movies, music, books, clothing, photography, nature, and so on. As you can see on the opposite page, my list of sources for inspiration is endless and very diverse. I like fashion, plants and women, but also horror and Harry Potter. I'm inspired by games and bloggers, stories from mythology, and music from Enya. I also look at trends, for example, in fashion or in comics, and pull from whatever speaks to me.

There is not always a big question or interesting story behind my work. Sometimes, it is enough to express a simple emotion or wanting to show my fears by drawing something that is terrifying to me. As a professional I mainly work as a designer, which means that my artwork has a function: it tells a story as I use my skills to convey someone else's message. My artistry and stories sometimes take a backseat to the task at hand. It's something I'm working on, the ability to take on more jobs where I can be free to express myself, along with the belief that there's value in my ideas.

Stay with yourself; there is no better way to create artwork

The fact that I draw inspiration from somewhere does not mean it's immediately reflected in my pieces. For example, I find sushi not only delicious, but beautiful. But it does not fit in my drawings and it would be really crazy to draw it in a piece. That doesn't mean I can't consider the colors and textures of sushi that appeal to me. Drawings allow you to look at the world and capture ideas for yourself and others. This works best when you keep things simple. The story that I tell with my own work is based on my life experiences. These are what I know best and they are the most authentic.

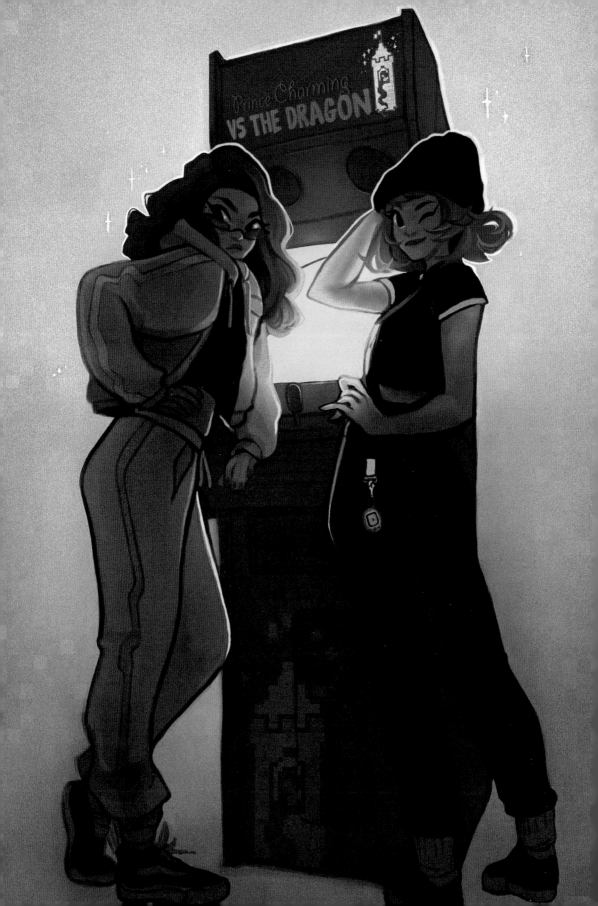

ARCADE

A lot of old-school sources can provide inspiration: characters, video games, 90's, fashion, etc. A drawing can be used for recognition without a deeper meaning. Sometimes people who aren't even seeking out my work, find me due to a series or game that inspired me. Sharing interests is comforting and often nice to see.

For the arcade and tamagotchi, I used photos as reference material because the characters and clothing are unique designs. The challenge for this drawing was to draw several characters in the same setting. Then, there must be interaction and the figures must come together, while also fitting into the composition. While the girls each have their own attitude and clothing style, it must be clear that there is a friendship. Classic cartoons often had the same clothes on the characters in each episode, like Donald Duck and Mickey Mouse, but in the cartoons that I liked to watch such as Winx Club and Totally Spies!, the characters each had a unique clothing style and many different outfits.

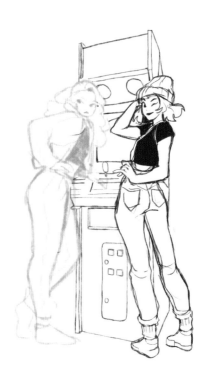

PROCESS

Here's how I drew Arcade, step-by-step.

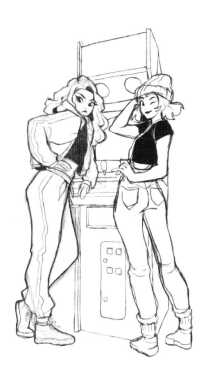
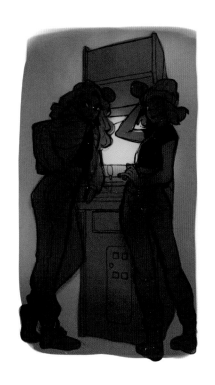
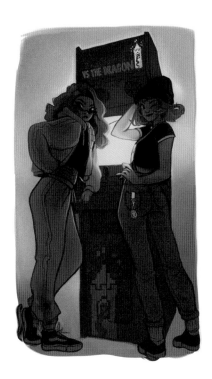
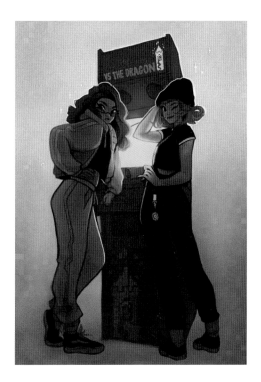

MAKE AN INSPIRATION LIST

You can draw inspiration from anything you like, from the art you love to your favorite snack, from the color of your favorite sweater to the music you like to listen to. Make a long list. You do not have to write your list in one go, but can add things as you remember them.

Whenever you get stuck on what to draw next you can refer to your inspiration list: there is always something that can inspire you to draw your next masterpiece or create a fun exercise. Perhaps you are inspired by it loosely, and the list brings you other ideas, or maybe helps you make fan art—whatever it is, it doesn't matter.

Don't dwell on the diverse content that inspires you. Just make your list. I am the type that rolls my eyes when I have to write things down, but if you make a habit of writing things down, you may eventually come across topics you had forgotten. If you are consciously trying to recognize your sources of inspiration, you'll find yourself more open and aware. I get so excited when I discover something new that I love or remember something beautiful from my past because I know it's going straight to the top of my inspiration list.

Collect

On a mood board, you can continue to explore topics from your inspiration list or do a color study. You can do this on paper, or digitally, like on Pinterest. I prefer digital mood boards because they're environmentally-friendly and I can access them on my phone anytime, anywhere. But old-school mood boards can add a really cool and decorative look to your creative space. I have a wall full of inspiring prints in my office, and a collection of different work in my living room.

Collect images of everything that you find beautiful or interesting. You can also save and construct your own collections on Instagram. No inspiration? Scroll through it. Share work with others. The drawings you make and how people see them can be even more effective for your process. And who knows, your work may end up on someone else's mood board!

MAKE A MOOD BOARD
Choose one or more themes from your inspiration list and elaborate on them using a mood board.

CREATE FAN ART
Choose something from your inspiration list or your moodboard that (preferably) still has no illustrations: a photo from the media, a scene from a book or film, or a song with an image. Make a drawing of this in your own style.

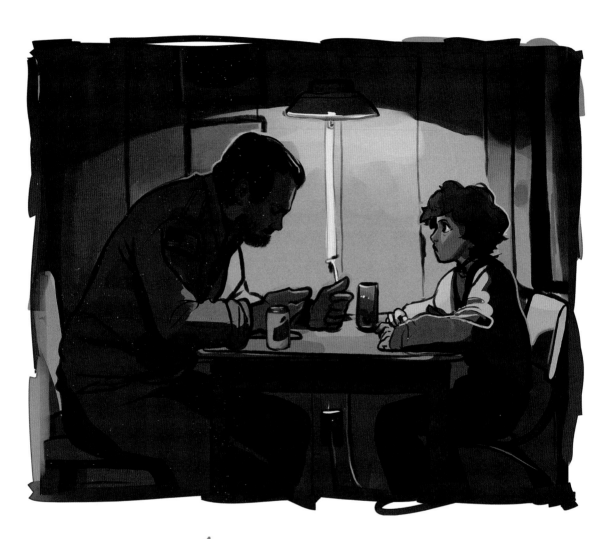

This sketch is a good example of a drawing that is incomplete.

HOPPER & ELEVEN

This sketch, which is still on my desk, was inspired by the Netflix series Stranger Things. You see Sheriff Jim Hopper and Eleven, two of the main characters, together at the table in the forest cabin where Eleven is being hidden. Jim brought a warm meal to prevent Eleven from eating just frozen waffles. This is clearly fan art, and I love the 80's style in which the series is portrayed, but it's also a good example of customization with my own style.

If you use a film or photo as reference material, then you have a real-life example of what something or someone looks like. Do you want to make your own version of it? The ideal drawing would be immediately recognizable by fans of the media as the character you depicted and also recognizable by fans of your personal style. You have to look for a balance between a realistic view and your own style. My figures are always cartoony and realistic.

Influence

Influence is something different than inspiration. Inspiration gives you the drive to draw when you are influenced by someone else's work. My style is influenced by manga and anime, but also by Disney and comics. My favorite comic *of all time* is *W.I.T.C.H.* from Alessandro Barbucci. I also use elements in my style from the Japanese anime, Paprika. I look at the work from fellow artists like Picolo, and also paintings by Oude Masters.

LIST

Make a list of examples of work by others (artists, designers, companies, brands) that influence you.

Share your sources of inspiration

Do not be afraid to share your sources of inspiration. This is true for fan art, but also for work loosely inspired by others. It's worth it to clarify whom or what has inspired you. It offers insight to the viewer, to the people who are involved in your work, and can lead to fascinating conversations. I have made many friends through shared passions and artists.

SEARCH & SHARE

Take a look at your Instagram account or other social media pages to see who shares your interests. You can also search specifically for artists in your area and see what they do and who inspires them.Go to events and seek out like-minded people. There are always more than you think. Go to films or exhibits, or organize meetings to get together and draw.

Your own style

Every artist has his or her own style, although it might not always be easy to see or describe. Think of it as a flower that has just been planted: the seed is already there, you must nurture it, and expose it to all the things it needs to grow to become as beautiful and vibrant as possible. Style needs time to develop and you can always make changes over time. You can be inspired and influenced by anything and everything. Nothing is more unique than your own style. By looking carefully at your own work and that of others, you can make choices that reinforce your style.

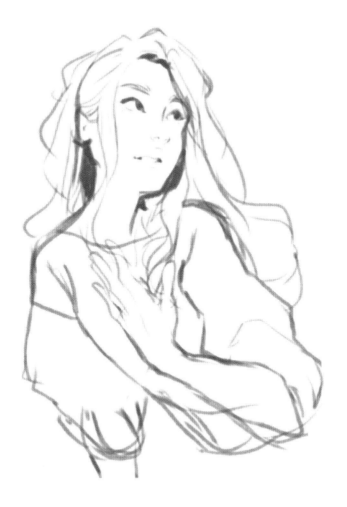

VANILLA

For Vanilla, I was inspired by a visit to the Museum Del Prado in Madrid. I wanted to experiment with light. The drawing was made using an entirely digital format. The composition is a semicircle and the details are all on the right side.

Over the course of time, my figures have become more realistic. They still have characteristics of manga (the big eyes), but they are more like real people and less like pin-ups. I work consciously and want more diversity in my drawings. You see a similar approach at Disney; the secondary characters are less stereotypical with more exaggerated features, but never the main characters. The main characters always look like the perfect star of their own fairytale, as that's Disney's signature style.

I used my own hand and nose for this drawing, and you can see that sometimes only a few brush strokes create the illusion of an ear or a shirt. In this drawing, it's important where light does and doesn't fall. The light comes from the left and right sides, but doesn't land on the neck where the hair is darker. Light also falls on the nose, through the hair, and on the cheek.

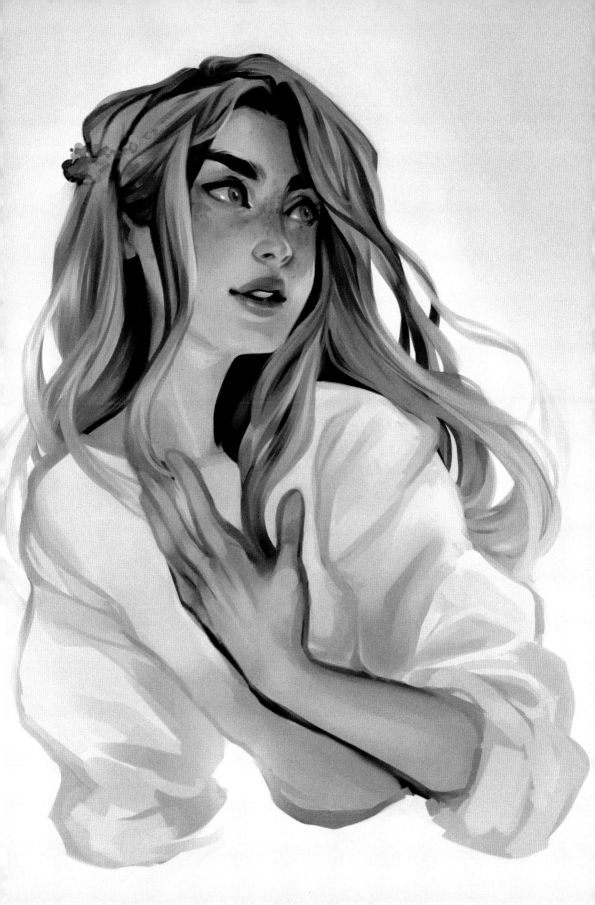

Style study

You may often recognize the style of others very quickly. As an example, I do style studies of two people I admire: the Brazilian illustrators Isadora Zeferino (@Imzeferino, illustration on the right) and Gabriel Picolo (@Picolo, illustrations on page 38). I am friends with them, but you do not have to know artists personally to analyze their work. The drawings that I discuss here seem to be related based on their color scheme, but are also very different. You can view and learn from these differences. Try out a variety of the techniques that you see in style studies. You do not always have to stick to the style choices you have made. In art, decisions are never black and white.

STUDY A STYLE
- Look at the list of work that stands out to you. This work can be divided into three large groups based on color use, theme, and lines. Categories that you can distinguish include cartoons, realism, oil paint, pencil, digital, abstract, figurative, and so on. Sometimes you can also assign subcategories, such as comics or manga.
- Choose a group that is relevant to your own work, or that you want to explore. If it's not related at all to your current style, dream up ways to integrate.

A FRIEND TO SHOW YOU THE LIGHT – IMZEFERINO

Isadora's style is narrative and often symbolic, with soft and round form. Her characters have a certain simplicity, which you sometimes see in children's books but also contain all kinds of complicated patterns. With this she fills in 'cut' surfaces, like the waves. If you examine the fish closely, you can see the small lines she uses. Her work is colorful, but she often uses soft tones. Isadora is inspired by animations, an area in which she worked before she became a freelance illustrator. Now, she makes accompanying illustrations for books.

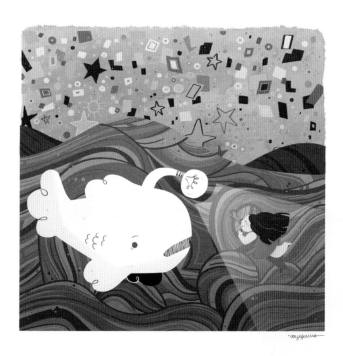

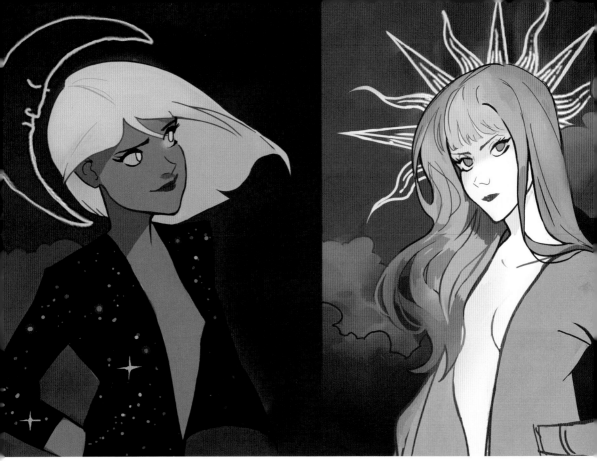

SUN & MOON
– PICOLO

In Picolo's drawings, you see that the lines and surfaces have been set up differently from Isadora's. Picolo uses little detail in the background and more detail in his figures, as with the clean lines you see in the hair, for example. Picolo's lines are not completely drawn, but put down as a suggestion. Picolo's work is influenced by animations and comics, and also by manga and video games, especially Japanese role playing games (JRPG's) like *Final Fantasy* and *Kingdom Hearts*. He has a sophisticated cartoon style with a sexy appeal. If you compare his work with mine, you see that he also works with shadows, but my shadows give more depth and thus make the shading even more realistic while he prefers the look of fantasy.

These drawings are from my good friend, Picolo who lives in Brazil. He is a freelance illustrator and comic artist. We have been in the same field for years. We are friends on both a personal and professional level..

STYLING ELEMENTS

When trying to find your own style, one of the most important elements to be aware of is balance. Balancing cartoons with realistic shading is one way that I achieve this.

To determine which elements work for you and which don't will take some experimentation. In the past I used complex color palettes, but Picolo's work has taught me how to use a simple color scheme.

- Choose a styled element of work by other artists that is not characteristic of your own style, something that you have not done before.
- Try to apply this technique in your own drawing. Consider how you should do that: how do you apply it? In what way does it connect?

Don't be afraid to be inspired by someone else. Just because it's coming from your surrounding environment instead of your own brain, doesn't mean it can't turn into original work. Go ahead, show everyone what you like about someone else's work! It helps to develop your own style. Just make sure to always give the artist credit. If you are doing a style study, then name where you got your inspiration from—artists appreciate this!

Do not be afraid to be influenced by others!

STYLE CHALLENGE

A style challenge is a fun and meaningful exercise to see what effect a style has had on a drawing. Here, you work one figure out in different styles. My version of a Disney princess or a Marvel hero is very different from that of a Picolo or Alessandro Barbucci version. Have some fun on the Internet trying to find examples.

DESCRIBING YOUR OWN STYLE
- Put together several of your recent drawings of yourself or look at an overview of your Instagram posts.
- Try to spot the general characteristics. If you already have more drawing experience and a more clearly developed style, then you may be more specific and indicate subcategories.
- Do you see your similarities and differences in the style of the artists that you have looked at in the style study (see page 36)?

Tip

Do you find it difficult to see the characteristics of your own style? Ask others what they see. Collect various comments and try chat groups. What do others say about your use of materials? What do they think of the colors? What themes or similar styles are mentioned?

Combination

Do not pin too much on one style—you can do different things. I make both comic-like work and more realistic drawings. The combination of different elements and styles makes your work unique.

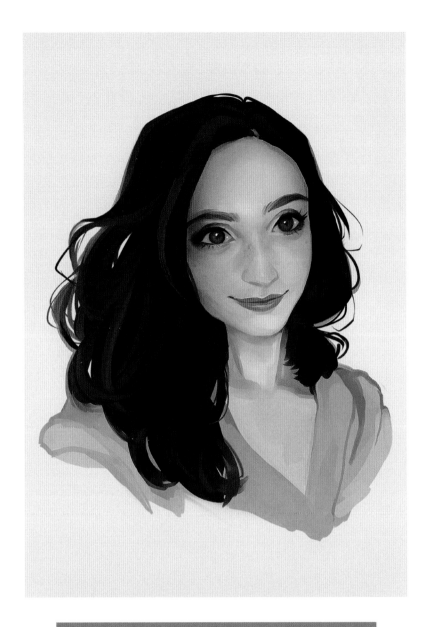

LAIA, CYNTHIA AND CLAIRE

On these pages, you'll see portraits of women that I find beautiful and inspiring. They are placed in front of something and the intrigue in their faces tells a story. In a portrait, I try to capture the natural beauty from the individual I'm drawing. I am careful to emphasize their best features.

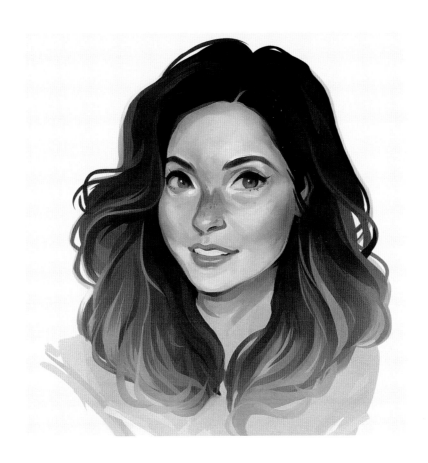

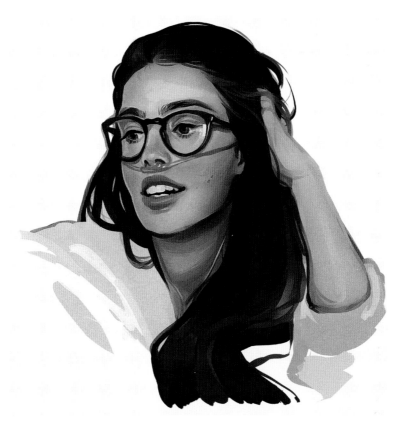

'You don't need fancy stuff'

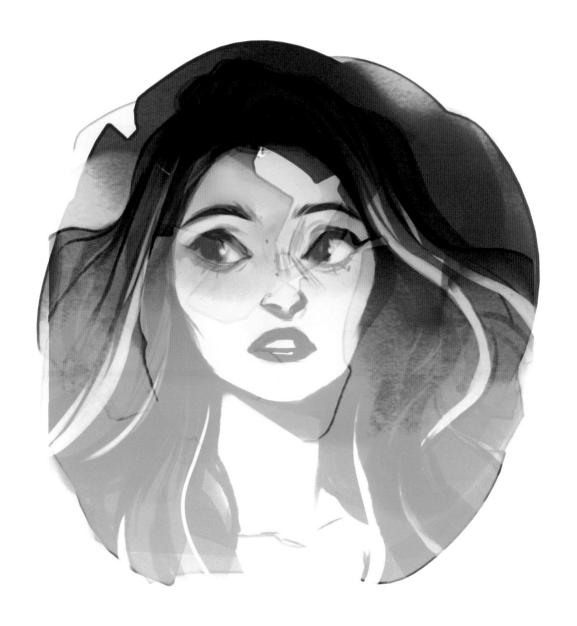

CHAPTER 2

TOOLKIT & BASICS

What you need

You do not need high priced materials to start drawing. I used to work with expensive markers because I saw others using them and thought they were necessary to improve my drawing skills. Fortunately, I learned quickly how to buy cheaper, more accessible materials—which can sometimes be more comfortable to practice with—and achieve similar results. You don't always need drawing paper; as printer paper is very suitable for sketching. The paper you use depends mainly on what you want to do with it: for example, some paper types will fail if you work with watercolor.

Tablets with pen pressure are fine to start with and your software does not need to be state-of-the-art. The only absolute necessities are whatever you feel is needed for an enjoyable session. In my case, that's music and coffee (a lot of coffee).

MATERIALS

Explore different materials and how they work together. Think paint, pencils, and markers. The ink of some pens can run when you color your drawing with watercolor. Digital allows you to view the effect of different brushes. Get familiar with all the different mediums.

- Collect papers along with a variety of materials (old or new) and work without a goal. Test out abstract forms for their effects Through practice you gain experience, through exploration you gain knowledge.

HOT AND COLD

I started this drawing as a traditional sketch; that's why I didn't immediately focus too much on details and perfection. I like how a rough sketch doesn't become too tight too quickly, and remains dynamic. There is a lot of difference in light and dark in this drawing, as well as a strong contrast between warm and cold colors. It's one of my favorites because I believe it shows my style and interests well. It can be fun to not know who you're creating until they appear.

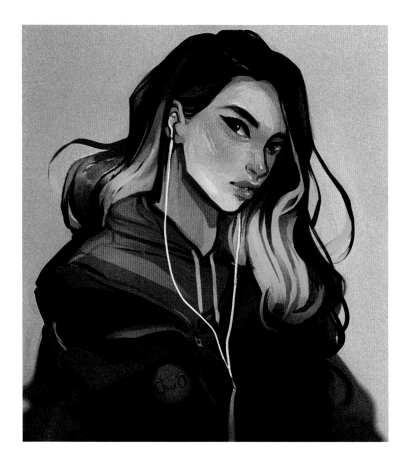

SEE CONTRAST

Make a drawing in black and white so that you can practice the contrast between dark and light. To see the difference, you can take a drawing that you have previously made in color and re-create it in black and white.

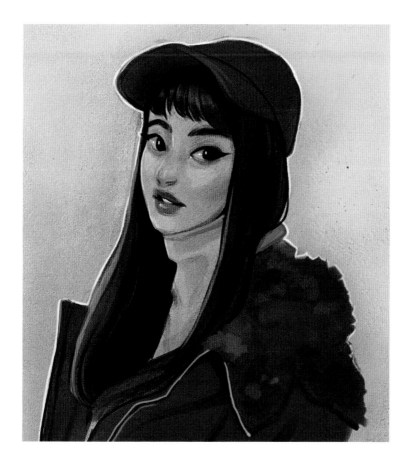

Digital vs. traditional

The choice for digital or traditional material depends on what you want to make. I sometimes sketch on paper, and later color digitally, but I also like to draw out pieces on the tablet. With a difficult composition, working digitally has many advantages. You can easily cut and paste, or start again. If you work on paper, take photos of the different phases. Suppose you want to go back to an earlier phase or start again; you can always use an uploaded photo to continue the work on your tablet. You can easily make complete color patches digitally, but I also often use traditional techniques. For example, you can use a sheet of watercolor to paint a photograph and use as a texture or overlay.

Scan or photo?

You can photograph or scan traditional work to continue building the piece. Photographing with the camera on a smartphone can often work fine. It is slightly more difficult when irregularities or light spots occur on a photo, but the image is less flat than with scanning, so you can keep the structure of the drawing paper intact. I prefer to use photos and then polish or remove any imperfections digitally. Pay attention to the preservation of quality when making and uploading photos.

For example, look at the difference between the two sketches you see here: the small sketch is a scan and the large one is a photo.

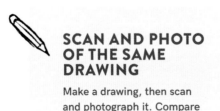

SCAN AND PHOTO OF THE SAME DRAWING

Make a drawing, then scan and photograph it. Compare the results on your screen.

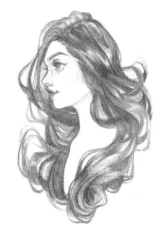

How do you take a good photo of your work?

- Photograph in daylight. Lamp light often gives unwanted shadows.
- Do not get too close to the drawing.
- Put an eraser or something else under your sketchbook so that it is not lying flat. Then you can take the photo by placing the camera parallel to the paper without blocking light directly above the drawing and creating a shadow.
- Sometimes I deliberately make a distortion of the image when I want to show a preview of a sketch. In that case, I make the angle extreme, and very close to the paper of one slanted bottom corner. This makes the distortion extra clear so it cannot be confused with bad proportions and drawing skills.

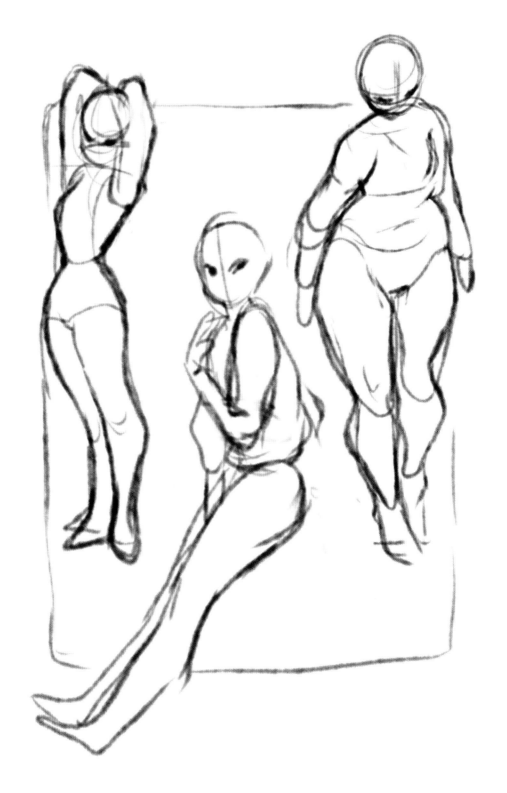

Sketch techniques

I have been drawing for as long as I can remember, without ever taking any kind of drawing course or training. I was very imaginative as a child, teaching myself was part of the creative process, needing to get what was in my mind down on the paper.

I also made cardboard skateboards and paper Barbie® clothing. When I was two, I won my first drawing contest. I had a coloring page with sideways Easter eggs and circles on the backside. My mother called it 'abstract Easter eggs.' The prize was a videotape of Bassie and Adriaan.

I was already drawing

For a long time, drawing was my main occupation. I have Asperger's Syndrome, a form of autism, and was bullied a lot in primary school. I left school around the age of 14 because I needed intensive guidance due to autism. I was always drawing, it helped me through that difficult time whether I realized it then or not. Later, I went with friends to the art academy and learned a few things on theory and listened to inspiring lectures from the people of Pixar. In the beginning I drew a lot, especially manga, and found people online who were interested in the same things. From those groups, we organized meetings and became friends.

I am not classically trained and cannot tell you the textbook version of "how to draw". There are all kinds of other books, courses, and training for this. What I can share with you is my experience, and what has personally helped me as an artist. I think these things are not only useful for beginners, but also for the more advanced artists. Do the following exercises in this chapter as a warm-up, and feel free to alter the techniques to fit your style.

Muscle memory

Each artist develops her or his own technique in one way or another. This includes body posture, the way you hold your pencil, pen, or brush, and the range of motions you execute. By drawing regularly, you create a physical routine and muscle memory. Your hand knows what to do when you pick up your pencil. I can easily draw people, faces, and cats, but cannot draw buildings with tight lines. Break your routine by making your sketches less repetitive or staying too long in the same static posture. It's good to get out of your comfort zone!

PEN GRIP: PENCIL, PEN, OR PUMP TO HOLD

Use this exercise as a warm-up before you sketch.

- Hold your pencil, pen, or brush horizontally, parallel to the paper, so that you can use the tip and keep it flat. Place your sketchbook at a distance and make it a loose, coarse sketch.
- Assume a loose posture (back, shoulders, neck).
- Put down your eraser!
- Put a lot of detail into your work—but nothing too complicated—spread over a large sheet of paper.

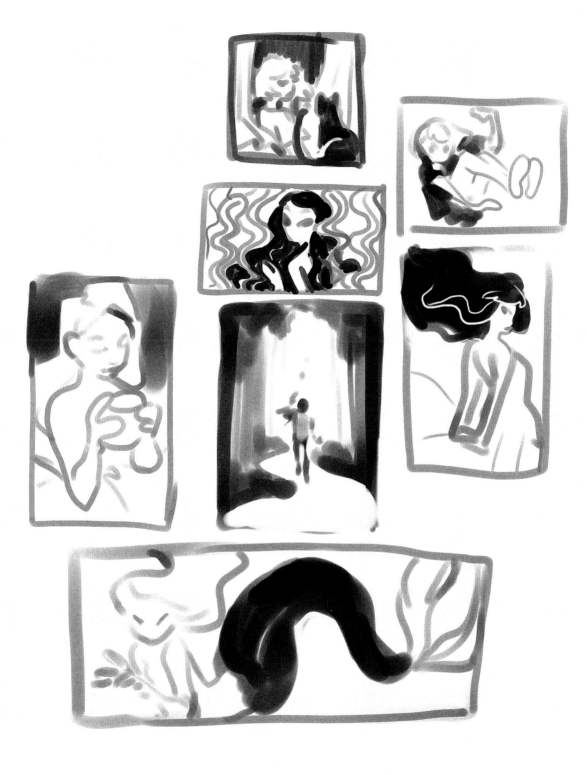

WARMING UP

Still no clear idea of what you want to draw? Feeling uninspired? Then don't pressure yourself with an empty canvas, make it easier and work from an existing image instead.

- Choose a photo or drawing from a landscape or city.
- Draw a figure (man, animal) or object (building).

You can adjust this exercise to your own preference. For example, when drawing landscapes, choose a photo of one figure or object (a building, for example) and design a background or landscape.

VISUALIZING DIFFERENT IDEAS

Before you work out a sketch, it is useful to visualize ideas in small thumbnails, simplified views of your drawing-to-be. You can then quickly see if a particular idea that you have in mind is going to work or not. You can also do it like a comic page, with different panels dividing your thumbnail ideas.

If you have little time

Lack of time hinders development and is a big obstacle for many people in school or working, so it is important to spend it well. I've been there myself and noticed that it's what you do with that limited time that really matters to your development. Suppose you can work one hour a day on a painting that will take you 20 hours, then you work on it for 20 days to finish it. But in those 20 hours you can do all kinds of smaller exercises to help you further your progress. Those 20 days become much more productive. For example, work on one

subject that you want to address for a month, and divide it into small pieces. Zoom in on the details of your progress and you'll see very clearly how each exercise improves your skills. Maybe it feels like baby steps, but all those little baby steps will help you develop, and you'll find that you are more easily engaged and motivated.

FAST SKETCHES

Making fast sketches of figures or objects forces you to simplify them, drawing only what is important. Practice your hand eye coordination—you have to look carefully at the essence you want to portray and translate it into lines. That's how I make sketches of figures, such as those on page 52. Working with a set time limit is a good exercise even for experienced artists who have no idea how long it takes them to work on one piece. As a professional, you have to know how much time each piece takes, so you can know how much to charge your client. These challenges help you develop that skill.

- Make sketches of figures or objects, always trying to work faster as you progress.
- Try to omit details. Set a timer and stop as soon as it goes off. It's okay if your sketch is not finished; take this experience to the next sketch you want to make. With this exercise, you'll learn to work both efficiently and effectively.

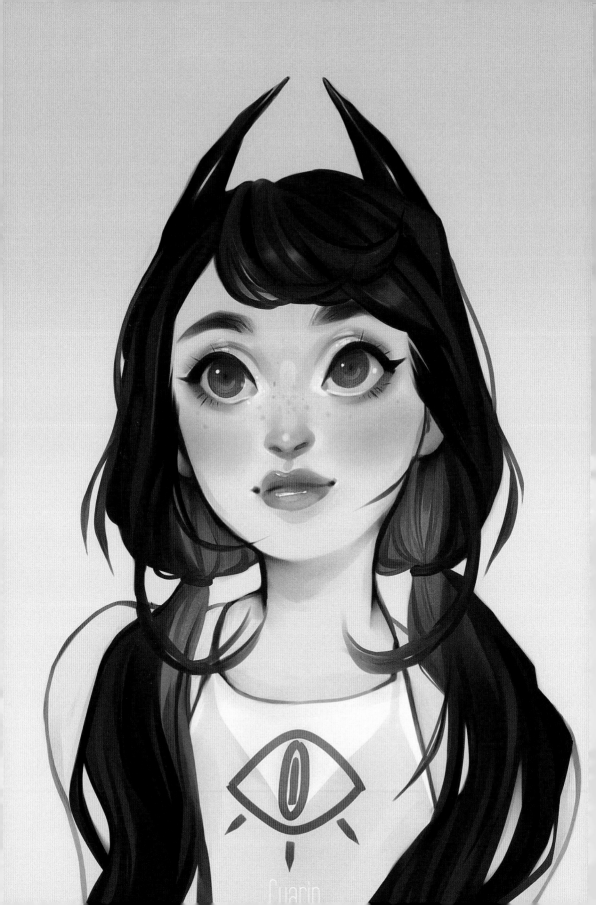

CHARACTER

There are many characteristic elements of my style in this drawing. The nose and eyes suggest manga, but the eyebrows and the mouth are much more realistic. The fierce colors make the drawing more pronounced and childlike, enhancing the cartoonish character.

I prefer to draw people, and I find it interesting to visualize character traits. Someone else may prefer to draw animals or landscapes, but I like to do character design.

When I work on a character in an assignment, there is often one mood board with colors and properties that I use. Usually there is a certain kind of feel, and I can imagine the rest. With colors and shapes already fixed, I can still choose the color in the development and shapes—such as in the clothing or hairstyle—that I think fits with that character.

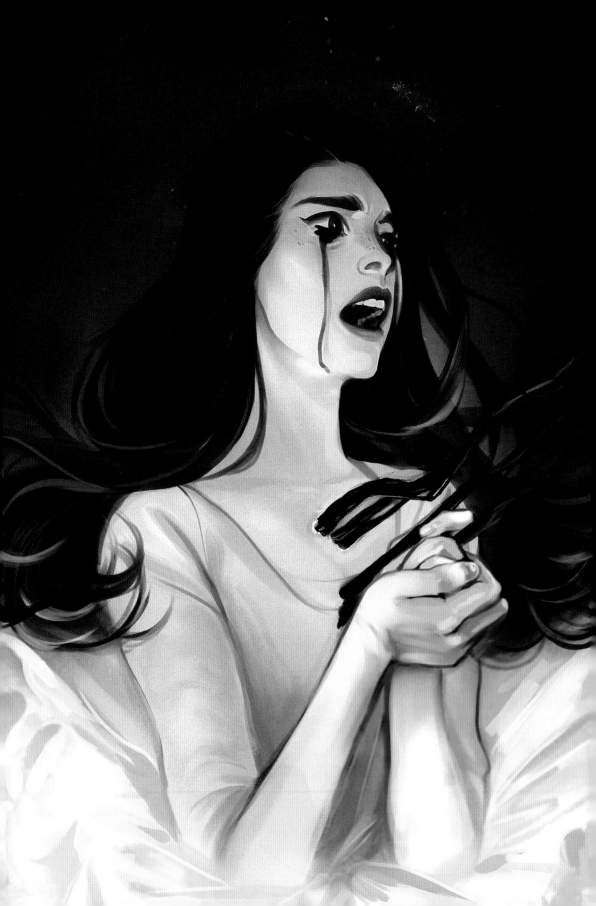

PERCER

This drawing is more permanent. I wanted a visually convincing, emotional concept. The character design is minimal but the looks are standard, and the hair and clothes have few details or unique elements. This helps to expand the concept, texture, volume, and flowing movements.

In drawings like this, people sometimes try to interpret my meaning and intention. Even though this particular drawing has no deep philosophical meaning, people sometimes express concern for me when they see it. Character designs can often be interpreted differently, and that's what I actually want to convey.

Outfit

For me, the fun part of working out a character is to design a matching outfit. Here, I can express my love for fashion and shoes by creating whatever I would like to have my characters wear. In addition to an outfit, you can also design an entire living environment such as a certain landscape or bedroom. You can design these parts based on pure fantasy, or find inspiration in the real world. After all, you are not a fashion designer, architect, or furniture maker. By using real world examples, your designs will probably look more realistic and credible. A rain boot must look like a rain boot and if you do not know that by heart, you better take a look at some pictures of rain boots before you design a pair for your character. If you wish to work realistically, don't just draw what's in your head—do the research. If you're a fantasy artist, dream up whatever you'd like.

On Instagram, my *outfits of the day* (see the following pages) are very popular. Those drawn selfies fit perfectly on this platform—the place where I find the most publicity for my work— and combine it with two of my loves: drawing and fashion.

The names of my drawings are usually just file names. I save the drawings that way, but the name usually has no meaning.

EXPLORE AN OUTFIT
- Choose a character drawn by yourself or your favorite hero from a movie or book.
- Design an outfit or other part of the figure you have chosen. Use reference material. My drawing on the opposite page was inspired by real sneakers.

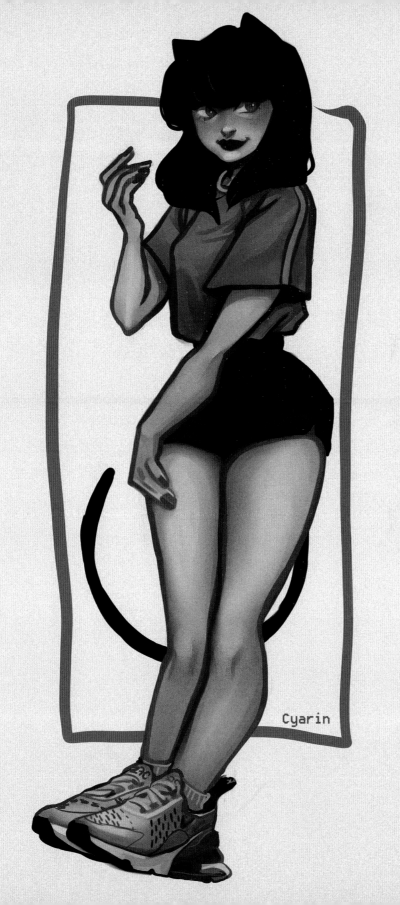
Cyarin

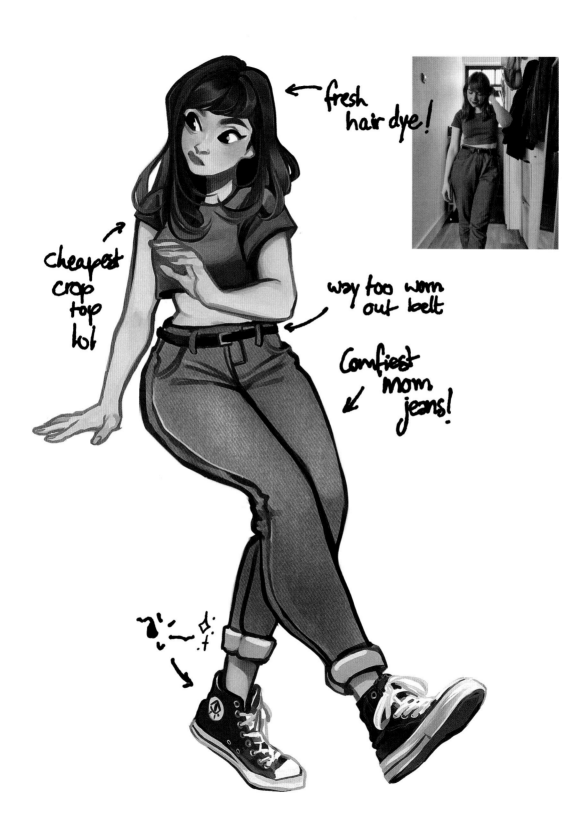

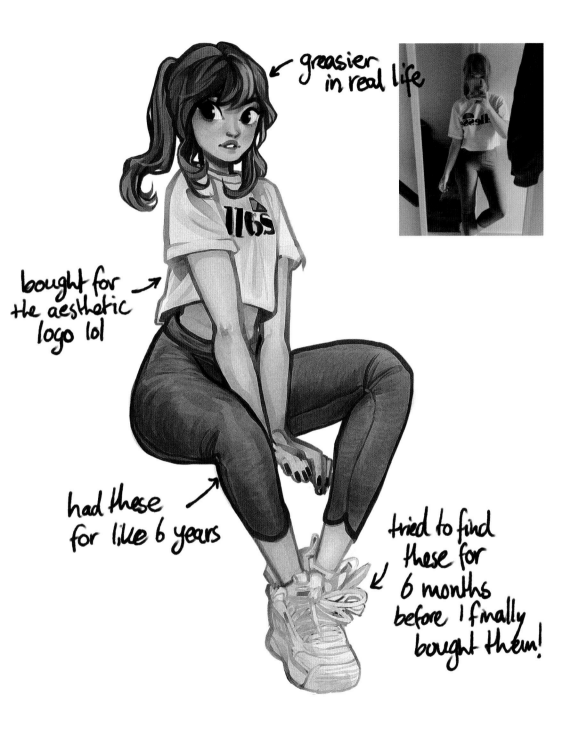

Shape

Shapes have an effect on the appearance and perception of a character. We interpret round shapes as soft and friendly; tighter lines are stricter and more dangerous. That is not the same as feminine and masculine. A muscular man's arm can be a very round shape or a woman's hips can be angled.

A villain is often angular and sharply drawn, like Maleficent or Cruella de Vil. In the Disney cartoon, *Sleeping Beauty*, angular and clean lines are used. Everything is angular and flat; even the trees are square. Child and adults alike have often referred to the classic as frightening. That is very different in Pixar's *Toy Story* where everything seems to be all round. The look of that film is therefore much friendlier and more childlike. In *Finding Nemo*, you see a nice example of the contrast between round and angular: small, innocent Nemo is round, but the dangerous sharks have angles. Mickey Mouse might be the most recognizable, classic example, as he is completely made of circles and cylinders.

DEMON SKETCHES

In the opposite drawing, you can clearly see what you can do with shapes. Although the demon girl is pointy and the monster has round forms, as the viewer, we understand immediately where the danger comes from and who the bad guy is by the contrasting asymmetrical and symmetrical forms. The combination of stereotypical and less stereotypical characteristics in a design makes one character visually ambiguous and more versatile. This way, you can create more complexity to convey personality, because the reader / viewer is subconsciously distracted. In the initial phase of my work especially, I think it is important to add these layers to your character. This is a good example of how I analyze my own designs.

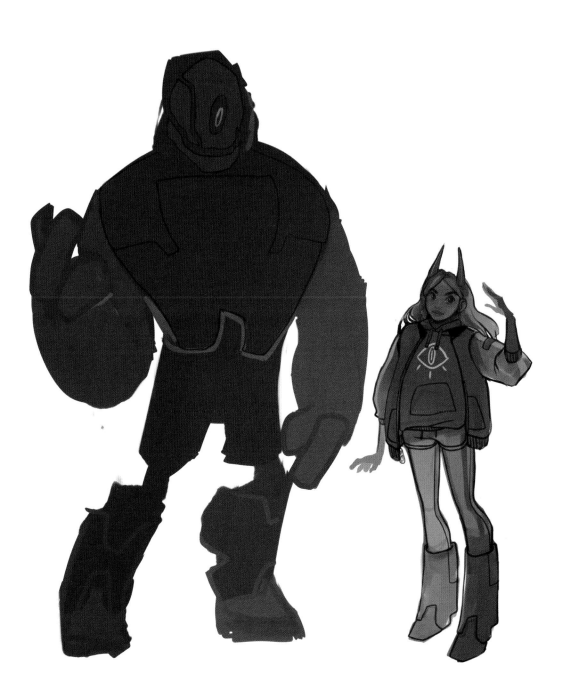

Unique

When I make fan art or a drawing based on a photo, I consider what is characteristic of that figure or person. What makes someone unique? What makes you more striking? An artist is free to express what they find attractive without conforming to conventional standards of beauty. People often do their best to look slim in photos, but in a drawing you can highlight someone's curves so that the results are stunning, yet eccentric. Recently, I sketched someone who was insecure about his ears, but I thought his ears were wonderfully unique so I drew them as they were. I think for the first time he could see the beauty that others saw in him.

In character studies, the forms are much more extreme than in real life as with caricatures. Mario and Pacman are very stylized. Manga is even more realistic—a stylized cartoon movement with subtle deviations, by drawing large eyes or very long legs.

LIGHT

This drawing is much more angular, for example, and has adult characteristics (see page 58). The color is more mature and modest. The digital techniques that I have used are similar to traditional painting techniques. For example, I often digitally paint in one layer and then try to use effect layers as little as possible. The colors and shadows were inspired by my salt lamp. I first studied how the light fell on my own face and then applied this to the drawing.

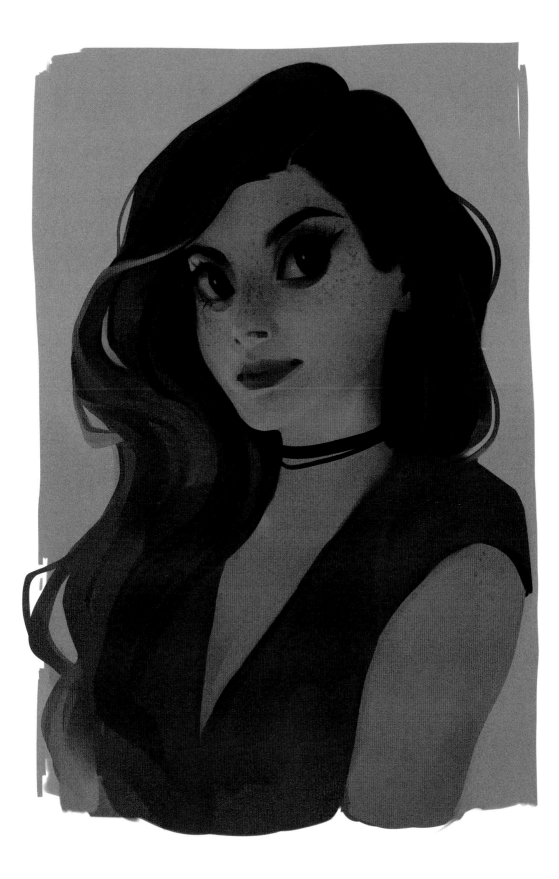

Color

The colors and color tones you use depends on your style. Realistic drawings or paintings are bound to reality, but in comics you can afford much more freedom. Lighter colored eyes often are more childish and "chemical," and the weakened variants create a more mysterious and serious feel. Colors must match the drawing. Natural green is more suitable for an organic form than neon.

In the case of color, *less is often more*: fewer colors make a drawing quieter to look at. But again, if you want to make your drawing more realistic, you may require more colors. *Light* (page 71) and *Translucent*, the drawing opposite, depict more realistic eyes by the quieter use of color. For example, see *Character* (page 58).

Black-Gray-White

I never choose black-black, white-white, or gray-gray: there is always a little color. Pure black and white are very hard, and unless I want to achieve an intentionally dramatic effect, I always choose a friendlier variant and add a subtle color, like blue to a black area, for example.

TRANSLUCENT

This drawing is dynamic and has interesting forms. The composition is in balance. If you divide the drawing into four parts, you see that the volume of the hair gets counterbalanced by the hand on the hip along with the elbow.

This drawing is made using entirely digital methods which clearly has advantages. Using the traditional way, it was much more difficult to create the skirt with that same transparency, and it is also easier to digitally color the surfaces so they get an even color.

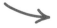

Values

In *Translucent* (see page 73), there is much more contrast than in *Vanilla* (see page 35), where the values are quite different. Those values of the different colors—the proportions between light and dark—must be well-attuned to each other. In a digital drawing, it sometimes seems as if there is a lot of contrast between two colors. But if you convert the drawing to black and white and see which values (shades of gray) you have, then there appears to be little contrast in clarity. Compare green and red: in color there seems to be a hard contrast existence, but when you put your drawing in black and white (desaturate), they appear to be close to each other in shades of gray. You may think that you do not see this if you work in full color, but too little or too much color contrast will disturb you. To discover if you need to change the color scheme, you can convert it to black and white. Compare the two illustrations on pages 75 and 76.

Sometimes you cannot see things with the naked eye, but converted to black and white it suddenly stands out.

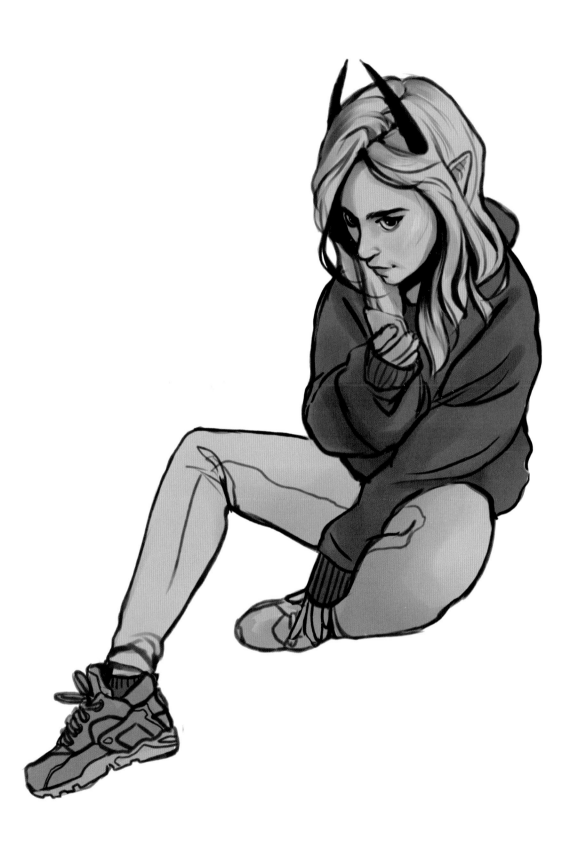

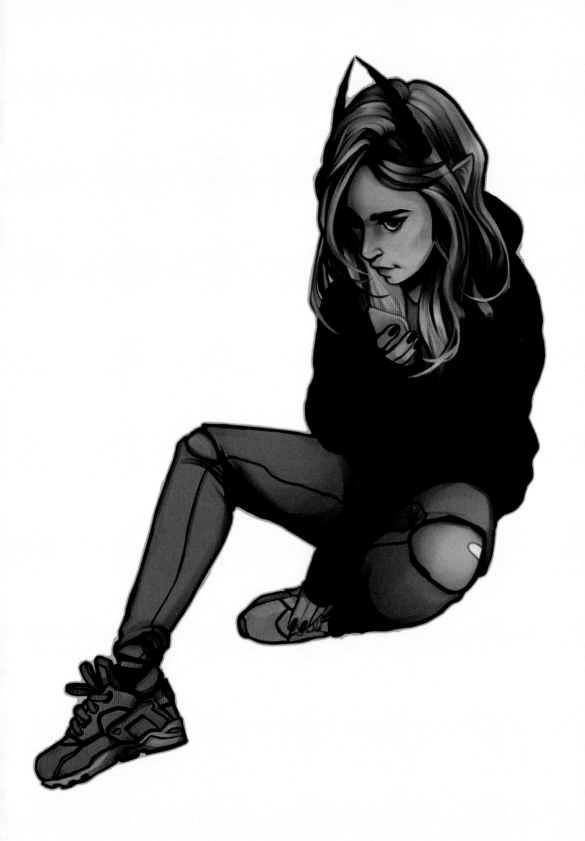

PERSPECTIVE

This drawing was a challenge. Someone pointed out to me that I usually draw people from the same perspective in the same angle. That stimulated my desire to try something new. Here, I consciously use another, more extreme angle. Sometimes you don't recognize your own flaws until someone points them out. Regularly ask for feedback (also see the exercise on page 138) and be open to change. It's how we grow.

VIEW VALUES

Compare the Perspective black and white sketch (page 75) with the color version. The contrast is there—certainly because in the drawing I have chosen little color—which is very important.
- Choose a color drawing of yourself with strong contrast.
- Create a black and white version, or convert a photo to black and white (desaturate).
- View the difference in contrast and assess your use of values. Are you surprised by the effect?

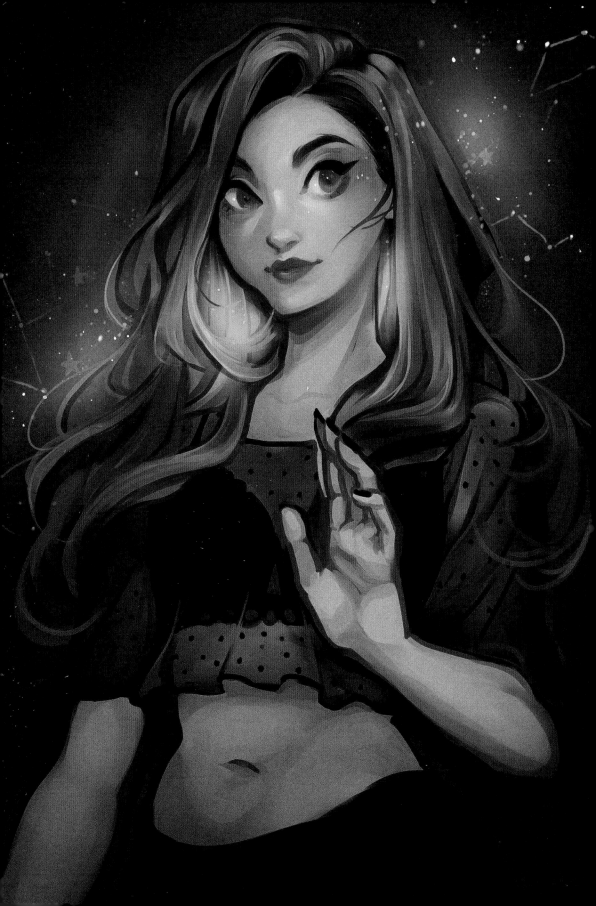

CONSTELLATIONS

My zodiac sign is Gemini, a creative sign, they say. I'm not sure how seriously I take the field of astrology, but it does interest me. The original *Constellations*, which I made a long time ago, is one of my most popular drawings. I don't remember having any clear concept for the eyes, as I was still very much looking for my own style. Recently, I crafted a new version with my more developed skills (see on the left).

This drawing actually has only two colors—red and blue—though they vary to shades of orange, pink, teal (blue-green), and purple. (I use these same colors in the original drawing). Apparently, I had an eye for this "less-is-more" principle, and the popularity of my drawings grew.

My tastes have changed, and my new drawing is clear and slightly darker. I now have more knowledge about light and values that influence the scene. In the newer version, you will see obvious technical improvements. Some people still find the older version more appealing, which shows how different personal tastes can be.

PROCESS

Step-by-step,
here is how I made the
Constellations drawing.

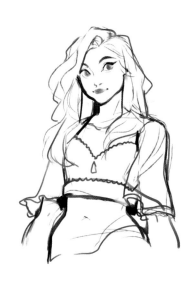

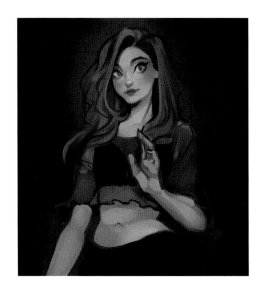

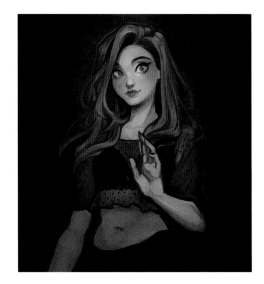

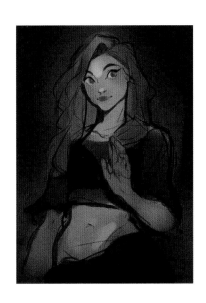
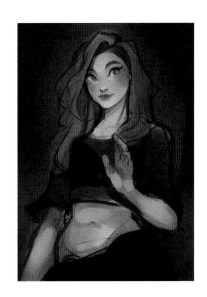
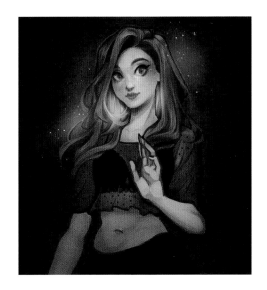
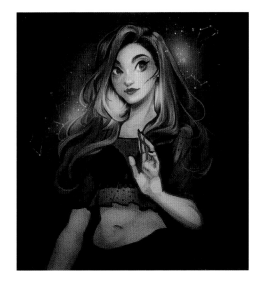

'Practice, practice, practice...
And know what you need to practice'

CHAPTER 3

NOT EVERY PRACTICE MAKES PERFECT

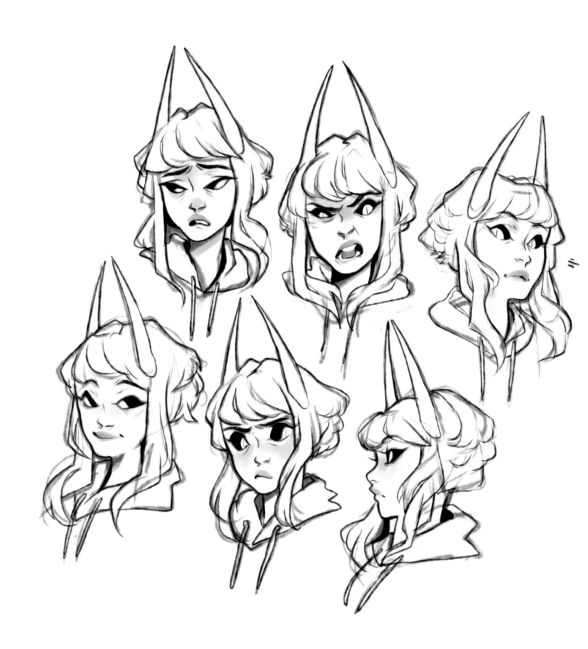

DEMON EXPRESSIONS

Practice, practice, practice. To get better, create as many drawings as possible instead of focusing on one perfect piece of artwork. Here, I tried to give the same character different kinds of expressions. The properties of the character must remain intact while you show different moods. You can practice what "angry" or "cheerful" looks like, how the facial features shift, and notice how the second emotion is less pronounced than the first. What changes in the face and what does not? When in doubt, look in the mirror.

Practicing also means that you make things that are not "finished" or "beautiful." The polished pieces you see online or in a gallery are not the only thing someone sketches. You never see what I throw away; I make a lot more than I upload to Instagram. Sometimes my artistic friends let me look at their studies and projects that are not yet finished. It gives new insight, that you normally don't get by just following people online.

Practice

In the beginning, one of my biggest mistakes was that I automatically thought I'd become a better artist with only complete paintings that had complicated concepts and compositions. I made piece after piece, but constantly got stuck because I didn't have the technical skills I wanted and my creativity ran out. Sometimes the failure paralyzed me and I wouldn't pick up my pencil for days. Instead, I played games for hours, watched TV, or read a book. Practice makes perfect, and that is true, but you have to know what you are making and what to practice. And practicing a skill is completely different than working on a piece.

Create unfinished drawings more than those that are finished

In many cases quality is better than quantity, but I've found practicing to be the opposite: you have to practice a lot and the quality of all those practice sketches doesn't matter that much—quality comes later. Create twenty unfinished drawings in one day and you've completed more than one drawing.

Do not limit yourself; practice in other styles. Don't just sketch only manga or animals or cartoons, widen your experience by trying new things. These fundamentals will help you, even if you eventually focus on one style.

Observe

In order to draw well, you must be able to visualize and see possibilities, while keeping angles in mind. Forget that a drawing is a 2D representation of something that is actually 3D. You cannot literally copy something, but you can use the idea of it to put shapes on paper or screen. The tricky thing is that it looks real and three-dimensional, but not all of that can show in your drawing: you can only draw what is visible based on the angle. For example: a nose has two nostrils, but they are not always visible.

Anatomy

If you want to draw human figures, you cannot escape the physique—
you must study anatomy. You can change the parts you find difficult
to draw or hide hands behind a back or in a sleeve, but that is not the
best solution every time. Make sure that when you leave something
out, you do it because you want to, not because you cannot draw it.
It has helped me a lot to know how certain parts of the body relate to
others. A forearm is equal in length to a foot, and when you hold
your arm along your body, the elbow is usually at the level of your
belly button. Do not hold on too tightly to "perfect" lines. A head is
usually an egg, but not always. See what you see, and then draw the
real form. For more experienced artists this is basic knowledge, but I
did not have that when I first started.

HEADS

Here you see how I am with fast
sketches, different attitudes, and
expressions. It doesn't need to
be immediately perfect; it is
about practicing.

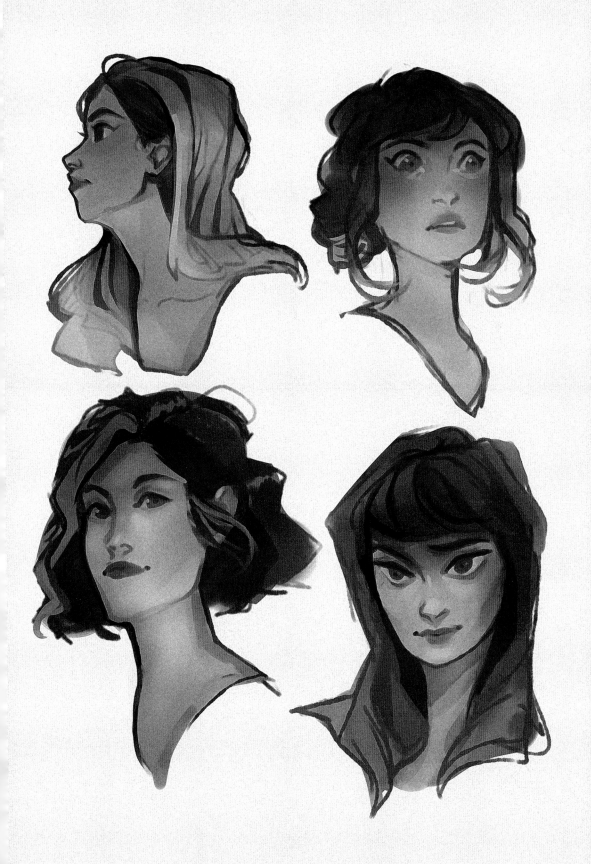

Simplified
shapes
this makes getting proportions
right a whole lot easier!

don't overdo details
in warmup studies, these
are meant to be done
quickly to loosen up & practice!

TRANSLATION FROM 3D TO 2D

Take a good look at people in different positions and try to reduce the shapes to sketch lines. You can do this with figures (see page 52) or individual body parts, like the hands. Depending on your style, expertise, or interests, you can also do this exercise with animals or objects.

OBSERVE AND ANALYZE

- Carefully review some recent drawings: which parts do you want to improve?
- View the topics or parts you want to improve upon in other images or real life. Compare with how you draw them.

These sketches show how you can simplify form. Every figure—like a hand—can bring you back to one small number of sketch lines, without details.

DIFFERENT VARIATIONS ON ONE FIGURE

Once you know how a figure looks in 3D and how it translates to a sketch, you can practice that form in different variations. Human or animal figures, body parts or faces: you can draw them in all kinds of poses.

- Choose a part that you want to improve and make sketches of it in different poses or from different viewpoints.

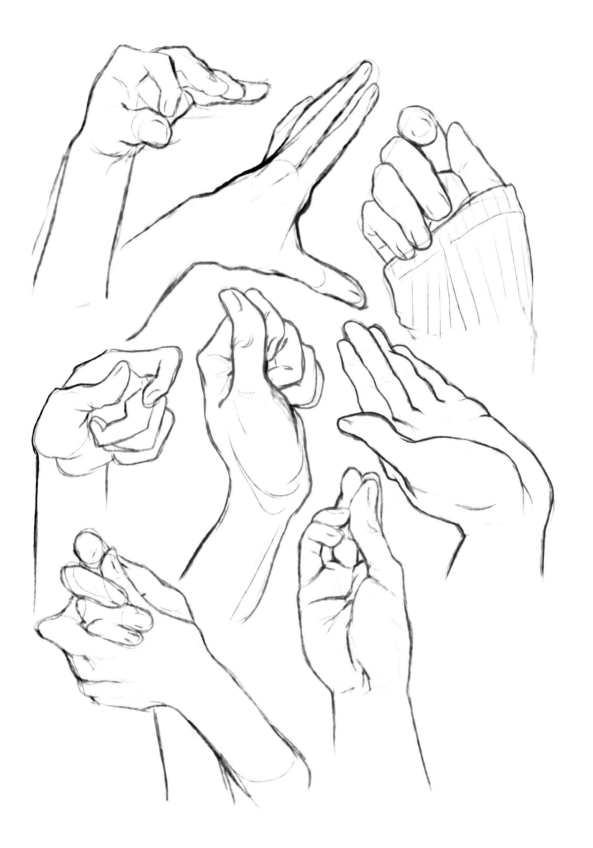

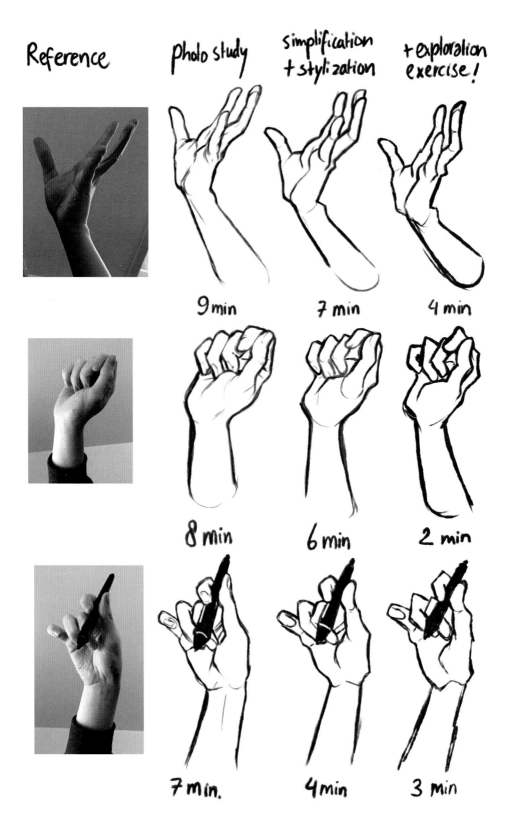

Reference

photo study

simplification + stylization

+ exploration exercise!

9 min

7 min

4 min

8 min

6 min

2 min

7 min.

4 min

3 min

After observing, work from reference material and more stylized exercises to draw certain shapes or parts in your own style. You can also challenge yourself with speed scales. On the following page, you can see that I needed less time with each sketch of the hand, because I became faster the more I practiced. I worked from top to bottom, and from left to right. The sketches in the right hand row are the last ones that I created.

APPLY YOUR OWN STYLE

With practice, you'll learn to make a 2D drawing of a 3D subject. You also want the drawing to be your own style.

- Create an accurate sketch using reference material (a photo) and draw what you see.
- Make another sketch in which you simplify the form to show only what you need.
- Now make a sketch with fast, strong lines. The better you get with your fingers, you'll learn to make more effective choices. Where you might need four lines in the first drawing, you might only have one in a later version.

REDRAW

OLD VS. NEW

On this page, you can see an example of a drawing that I've made. Above is my very first digital drawing. I used free software that was not at all meant for drawing and completed the coloring with a mouse. Next to it, you see the redraw that I made for this book. The progress is evident here, especially in the improved technical skills. The anatomy is better, I know my material, and there is minimal sloppiness. On pages 98-99, you can see how the redraw evolved. You can also clearly see that there are quite a few changes.

PROCESS

Here is a step-by-step view of how I made this drawing.

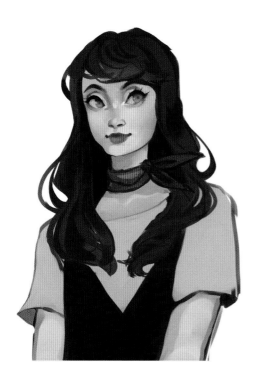

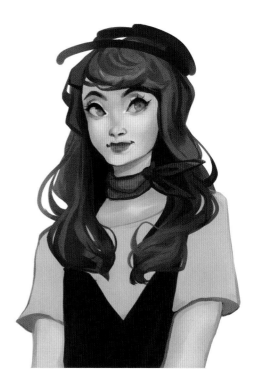

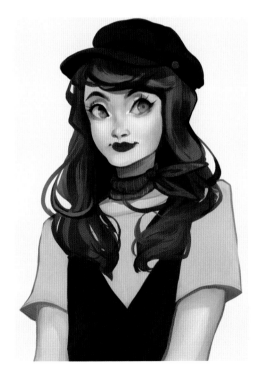
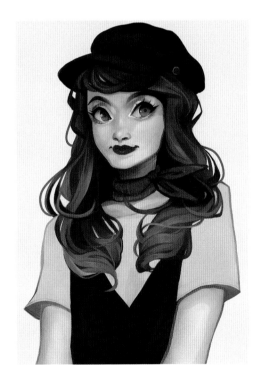

NOT EVERY PRACTICE MAKES PERFECT

'A drawing is never finished'

CHAPTER 4

FINISHING TOUCHES

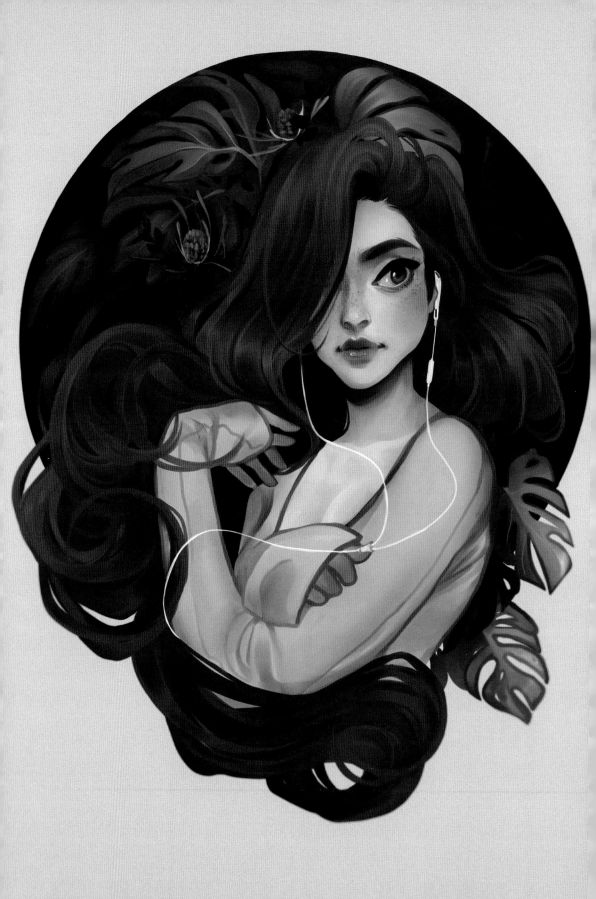

DELICIOSA

The plant (*Monstera deliciosa*) was my source of inspiration. This drawing showcases my skills and was very much in my comfort zone. In the different sketches on the following pages, you can see how I made changes and which effect I used. After rendering, the drawing was roughly polished. When finished, almost all of the raw material disappeared.

Using color, you can show relationships or make connections in your drawings. I used to rely on too many different colors. For example, I had the shirt colored blue in this drawing. But that was too distracting, which is why I chose a more neutral color, one that does not stand out. The contrast I sought was in the red of the hair, the green of the eye, and the background. The blue-purple thistle flowers offer additional variation in color, and this detail attracts the eye to the background.

I started this drawing with the pose—a heart-shaped composition. I found the attitude of Sketch One beautiful (see page 104), but when I added color in Sketch Two, I felt like something was still missing. I liked the overall picture flat and distant, a bit like art nouveau, which can be cool. In Madrid, I saw an exhibition about Alfons Mucha that was very beautiful, but a little too personal. That was a conscious choice, because his work had a design function—it was advertising material—but very inspiring to see sketch work with strong emotions. I would like more of myself in my work. In Sketch Three, I turned the head because the previous image did not feel warm enough. I also added headphones, a modern element, as a contrast with the organic illustration, which immediately gives an indication of time. In Sketch Four, you see that the expression is more intense and there is more contact with the viewer. The eye color now has a clear relationship with the background.

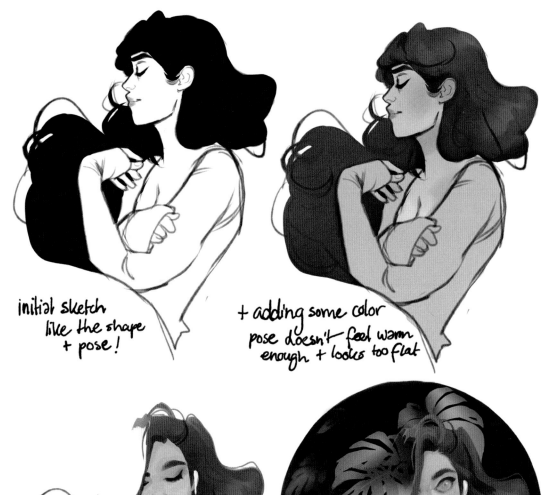

initial sketch
like the shape
+ pose!

+ adding some color
pose doesn't feel warm
enough + looks too flat

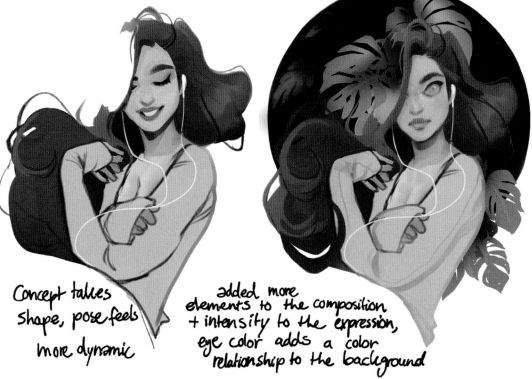

Concept takes
shape, pose feels
more dynamic

added more
elements to the composition
+ intensity to the expression,
eye color adds a color
relationship to the background

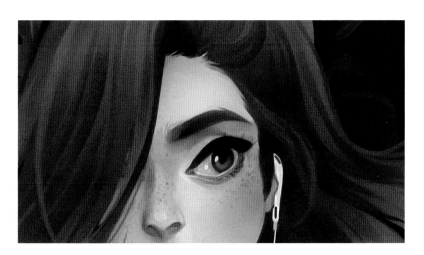

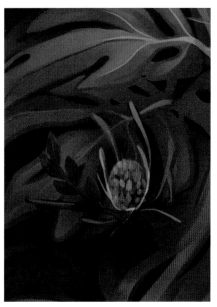

details: Monstera plants
are a mild obsession, oops

Rendering

Once you have a sketch that you are satisfied with, then digitally finish your piece—go from sketch to finished artwork. This is also called rendering. If you want to keep more detail or make the drawing more organic, you do not have to render every part. In *Vanilla* (see page 35), the details in the hair and the hand were preserved, causing the viewer to look at it longer. The shirt is much less interesting.

In my view, a drawing is never finished, but by posting it and thus showing it to others, it becomes definitive. Remember that the number of likes can say more about the subject of a drawing, than the actual quality of the execution. People like a piece of artwork more when they recognize something in themselves.

Doubt?
Leave your drawing for a day.

Much of what is done in rendering—coloring, shadow, and adding depth—is routine work. You don't have to do it all day long, and if I feel inspired by something else, I set rendering aside for a bit. Also, finishing is the trickiest phase and I often avoid drawings because I do not know how I want to finish them. When in doubt, leave the drawing and consciously spend a day away.

OBSERVE TO UNDERSTAND RENDERING
Look at your work as if it were someone else's, and also look at work from others. How do they do this? How detailed or sketchy is a drawing? Which parts attract attention to light and shadow or structures? What is "finished" for one is a rough sketch for another; there is no "right" or "wrong" with rendering.

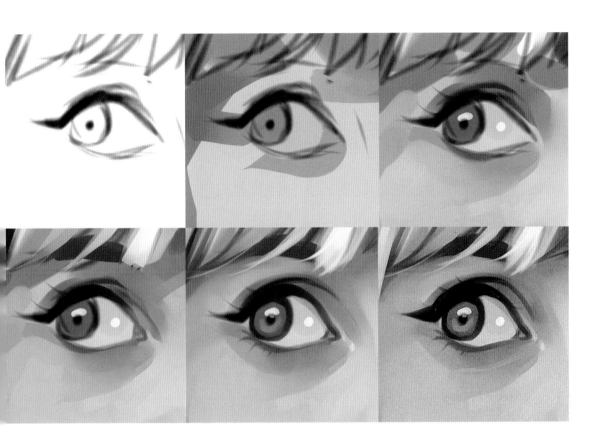

Above, you see how the sketch of an eye is worked out. I add color and light and give the surfaces more structure and depth. The eye is tighter and more lively after rendering.

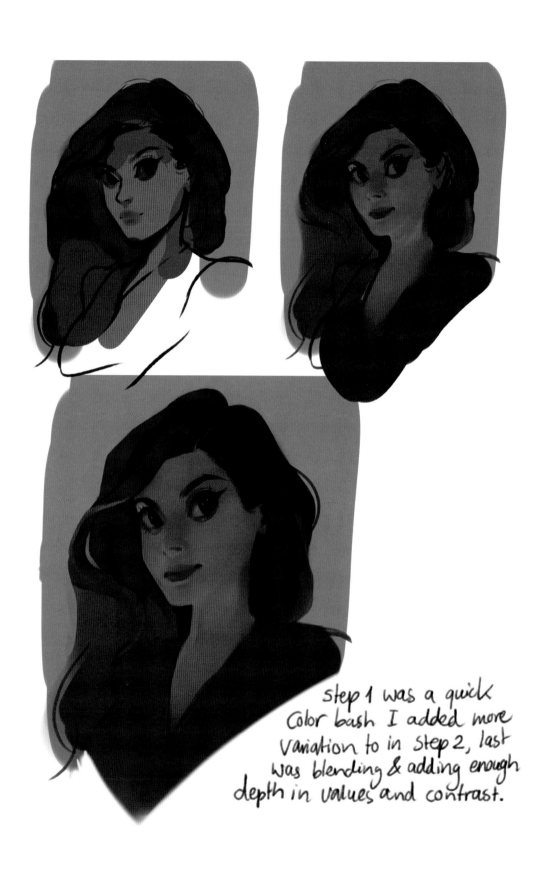

step 1 was a quick color bash I added more variation to in step 2, last was blending & adding enough depth in values and contrast.

Video

The process of rendering or working out is very long and difficult to print in a book. Therefore, I would like to share this exclusive video with you, in which I explain an elaborate process for one of my drawings.

On the opposite page, you see a number of steps in the finish for Light (see page 71). On Sketch Two and Sketch Three, you can see the difference in the finish of the jaw.

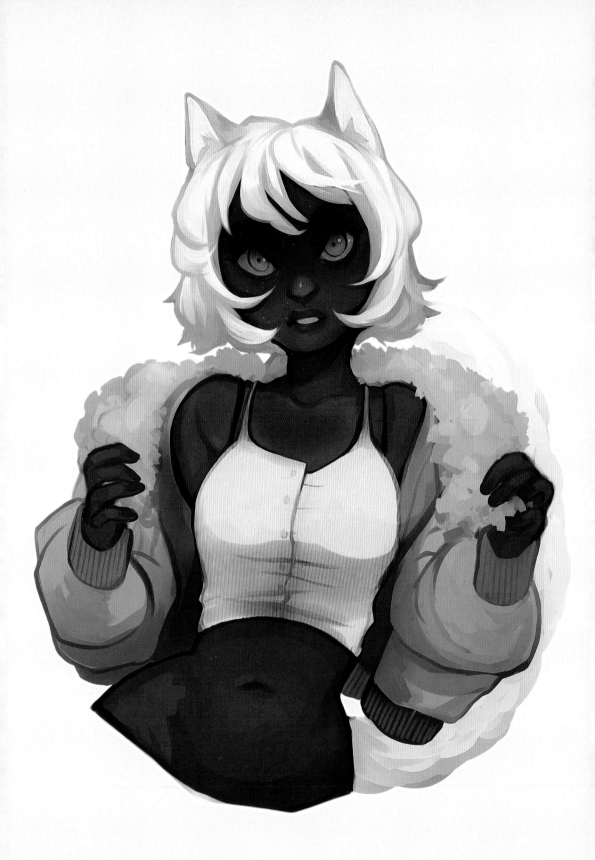

FUR COAT

If you compare this drawing and *Deliciosa* (see page 102), you can see it is good that much less time has been spent on rendering.

When finishing, my emphasis was on the face and the hair. You can see details in the face and the hair, but the fuzzy roughness of the fur jacket is retained in coarser broad strokes. Because the skin is dark, your eye is drawn there. In the fur collar, I have applied structure and shadow, just like in the cuffs and the top. The rib structure that you see is made by hand, just by pulling lines. Once in a while, you can also load a structure before creating the background, such as the pixels on Arcade (see page 24). But I prefer brush techniques when working with the texture of objects or clothing. With shadows, I can see the illusion of shining to create dust. You can see a lot of rib and shiny materials in fashion and on many selfies. I handle such fashion trends like an illustration.

Blending

Overblending, not stopping on time, is a common mistake. That is why it is so important to preserve different phases. Once in a while you do something you didn't mean to do and it's handy if you can return to an earlier phase.

You can load different versions of a drawing digitally. You work in the top layer, but can go back to one by erasing an earlier version. You can then combine these two layers into new ones. This is advantageous because you can preserve your last version. If you have to go all the way back to a previous version, then you lose everything you did in the latest rendition. This is why I habitually save my work. I often use the advice, "Leave it a day or two." You can sometimes lose sight of the big picture, especially if you have been out of the operating phase. A fresh look is super helpful!

STABILITY OF THE HAND

As you draw more, the stability of your hand increases and you develop character muscles. This allows you to draw circles and straight lines more easily (with ruler-drawn lines, eyes look unnatural). Quickly outlined circles and straight lines often work the best.
- Sketch a whole series of circles at high speed, followed by a whole row of straight lines.
- Try again, but go slower.
Do not use this exercise before sketching, but as a warm-up when you want to work neatly with rendering, or as a relaxing warm-up when you're in an art block.

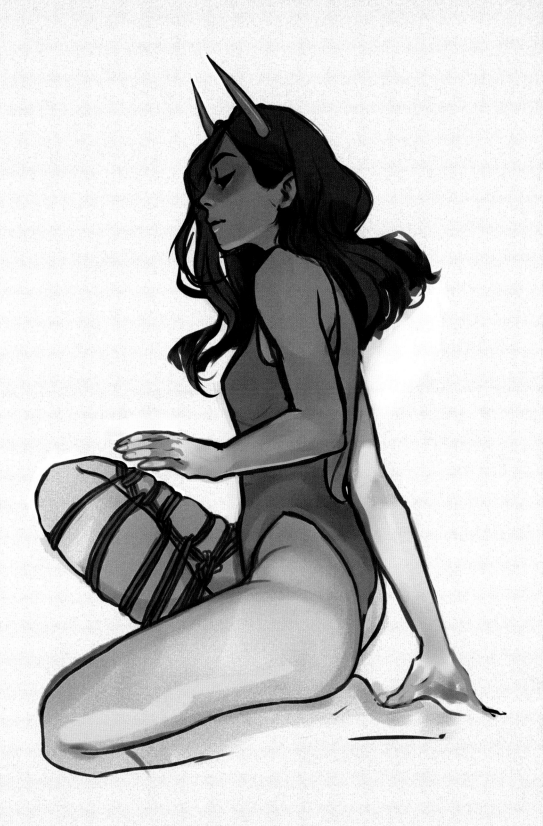

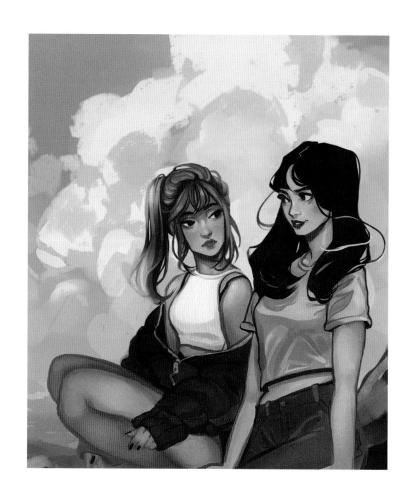

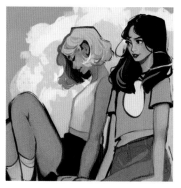

PROCESS

The background of this drawing is very rough and picturesque, while the characters are sharper when rendered to create depth. The lack of strong contrasts in the background makes the scene calmer and attracts attention to the facial expressions. The interaction between the girls is where most detail and contrast is presented.

In this drawing, I wanted to see interaction between the characters and create a more complex background. I made something outside my comfort zone, but only a small drawing, because I also took into account what others would like to see. Sometimes I do what others expect from me instead of drawing what I want.

As you can see in the various steps, not only did the girl on the left change over the course of the process, but I also struggled with the color schemes. I didn't want the colors to become a distraction, and they had to be pretty realistic but not boring. The drawing of the clouds was therapeutic. I do not like calculating, fitting and measuring, but I find it easy to draw organic structures.

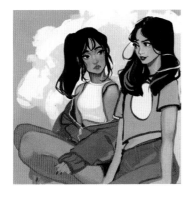 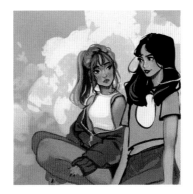

'Find your own place for your work in the industry.'

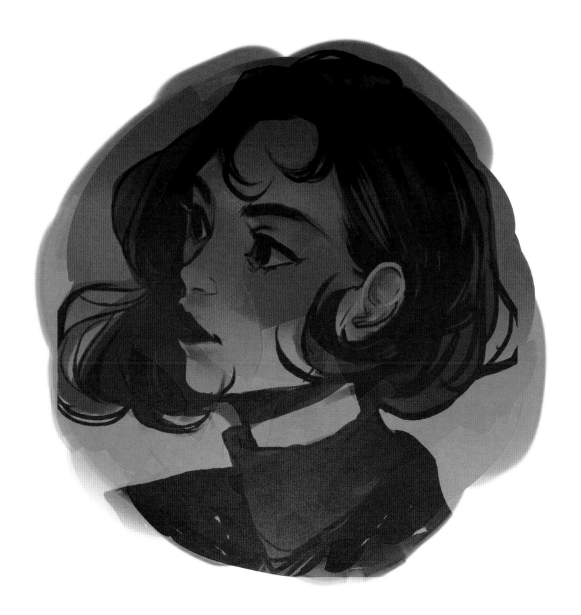

BECOMING A PRO

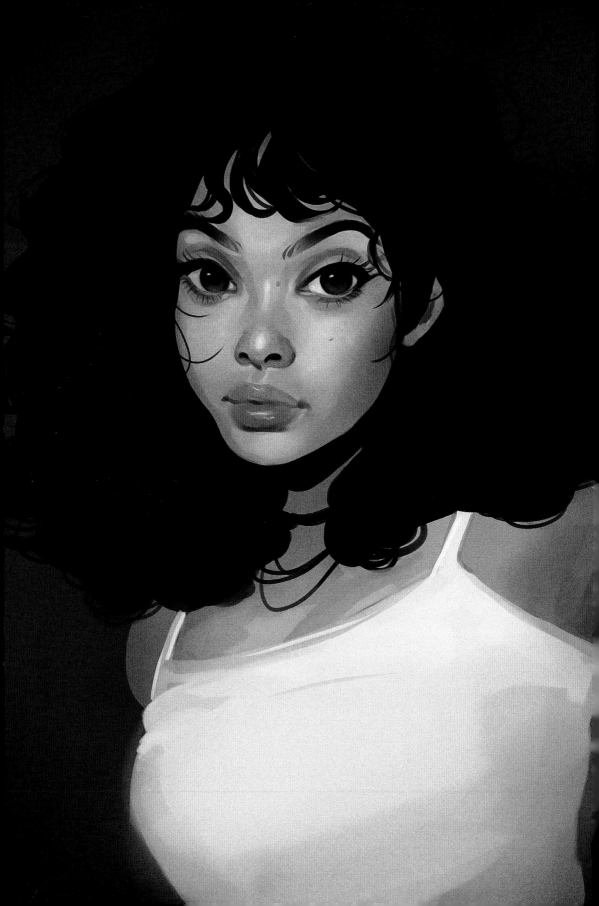

FIJI

I created this portrait based on a photo. It is an example of work that I made on commission. As soon as you start charging for your work, you have to make agreements about finances, and also pay attention to the copyright.

Often, the work you do on assignment does not belong to you, but to the client. You can not just use it on social media or in a book. Think of portraits: someone needs to give you permission to use her or his image. Of course, you can make portraits for yourself. The same applies to fan art. Drawings that you base off of existing images—whether from Disney, Pixar, Marvel or individual artists—are fine for personal use and can be shown on social media (think of it a source reference). If you plan to start selling the work, you will need permission. If your fan art gives credit to a clear source of inspiration on a small scale, but is sold without permission, you need to make sure that you seek legal advice and do things the right way.

Own spot

I always worried my work was not relevant enough, but your pieces will sometimes have more value than you think. People see me as an artist, but I am more of a designer. Design is always influenced from the outside and has a more concrete function. Art is only created by you, from your own thoughts. You see design in everything around you. The packaging of one breakfast cereal is different from that of another brand (and milk cartons look different).

I'm a designer, not an artist

What I create on commision, such as the design of the clothes of toy puppets, will affect the user. Also, my own work (the pieces that I do not commission) always has a function. I tell a story, and it is never abstract. My drawings are exercises to convert words into images. For example, I want the people who see my work to think about stereotypes or relationships. But that's just my own personal niche, someone else's may look very different.

Modern revolution

I see friends reform the comic industry by creating trendsetting work. We are part of a modern revolution. Our world is more accessible and there is social media for inspiration, access, and feedback. A large part of the process is shared openly, making the art industry more collective and community-oriented than it's ever been. Instead of being a fan of a character, you might be a fan of the illustrator. There are also fewer gatekeepers and rules so people discover for themselves. Other cartoonists can see you on social media. There is plenty of room for diversity. Based on experience, you can put something down and show it to others, just like me.

Don't believe people when they say that manga drawing will never get you work. My experience is that if you like it, it's worth it—there are always others who will appreciate your work. Your opinion is just as valid as that of another and you can find your own place in the industry.

Business

I used to think that being an illustrator was not a profession. But since my 19th birthday, I've been an entrepreneur and can live off what I do. In the beginning, my income was from assignments for companies, but now I have such a big fanbase that the sale of my own work is my main source of income. Other money comes from sponsorships. Companies send me products such as clothing or drawing material to work with, which I then add to my drawing process. If I make a post about it, I will be paid for it. Also, I am sometimes hired as an influencer. I work well on assignments from companies and would rather do more of that work, but that is just how business goes. You have to be able to deal with change.

I used to think that illustrators had no business appeal

Business side

It is good to realize that it is okay to charge people for your work. People sometimes ask me to do something for free "out of love for art." It used to be so difficult to refuse, but making art takes time and your time is worth money. Be sure to give value to your work. Any important potential customer will understand. Or you can hire someone—a manager, assistant or agent— who can do business for you and say no on your behalf.

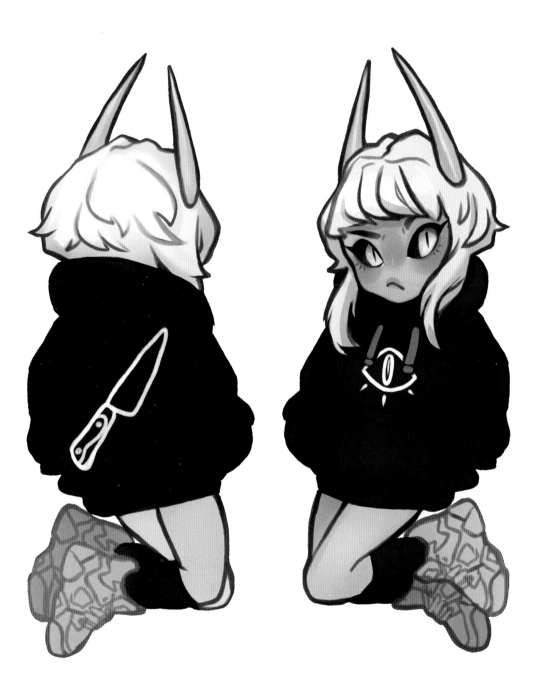

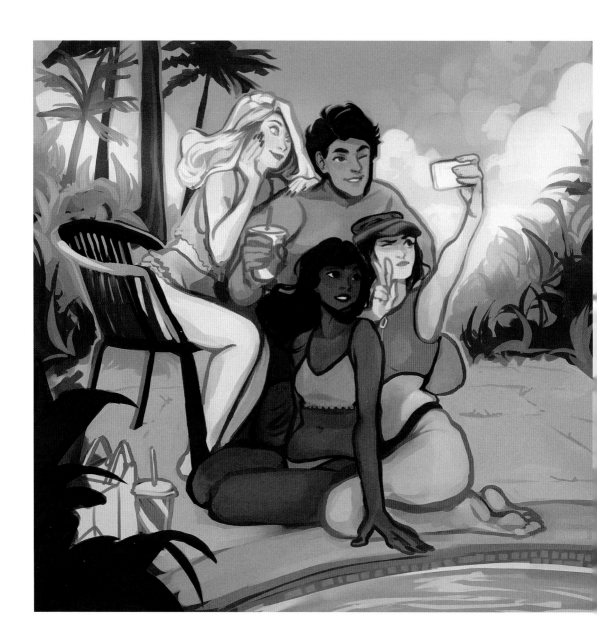

GROUP SELFIE

This is an illustration that I made in June, the month of the LGBTQ Pride celebration. I wanted to create something cheerful with a lot of color. I challenged myself to draw the interaction of multiple figures.

The colors are matte and I kept the style cartoony. Your attention goes to the faces, where there are more details than in the background. In the steps (see the following pages), you can see how I built the drawing. I began the composition in light and dark planes. Every figure had to be natural, and take an organic pose. Because there are multiple characters in the illustration, I used fewer colors and ensured that they matched well, otherwise it would be too busy. The foreground has warmer colors and the background is cooler—this is a standard technique for depth with color. In my rendering, I used a warm color filter which added a summer touch.

I made this drawing after I made Forest (see p. 18) and felt much more confident and comfortable while rendering the drawing with a background. I could better deal with the rougher background and it was easier to finish this drawing, simply because I had done it before. Challenging myself brings me so much further in my work.

PROCESS

Here is a step-by-step look at how I made the drawing "Group Selfie."

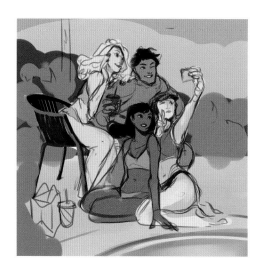

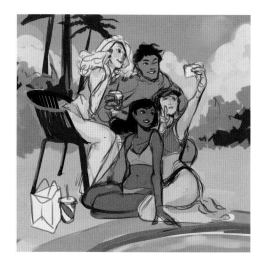

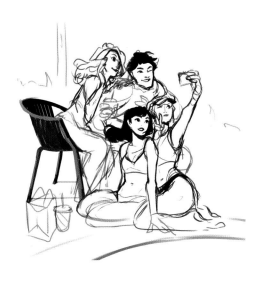
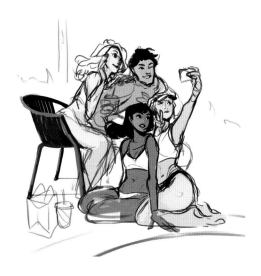
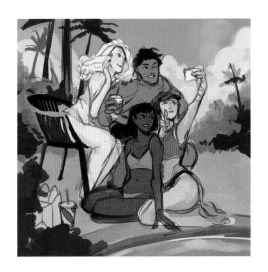
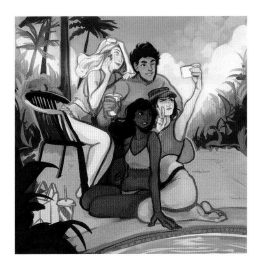

Are you a specialist or well-rounded?

If you have a specialty—a clear characteristic—you will build a brand faster. But being well-rounded also has its advantages.

Social media

I definitely recommend using a social media platform like Instagram. It is easy to learn and you will find people who are interested in your work relatively quickly. You can also find smaller groups with the same interests, as I used to do.

There is very little pressure, you can only post what you want your followers to see, and you can also do giveaways to gain visibility and more followers. Remember that followers you gain from giveaways, may unfollow you as soon as the giveaway is over. Post what you like, it's your page and you can do what you want.

People like to portray themselves as perfect, especially on social media. I tend to not follow those who show a distant, perfect image of themselves. I know that people appreciate my openness, and sometimes people even feel that they know me personally. Think about sharing personal work and messages about your private life that potential clients can see.

There are other ways to bring attention to your work, of course. There are festivals, fairs, exhibitions, and conventions to take part in. Visit exhibitions like *Comic Con*. My experience is that this creative industry allows you to quickly make personal contacts. Keep in mind that collaboration is fun, but if you often work with several people, you may be less focused on sales or profit.

To get to work in this industry, it is important to know what you like. This is the first step. Don't fill your portfolio with work you're not interested in simply because you think it's good in the market. You'll just get frustrated or burnt out. Instead, share what you are passionate about, and clients will hire you for projects that you enjoy.

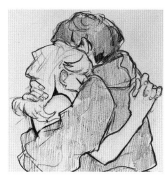

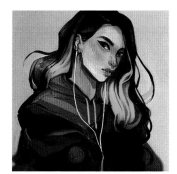
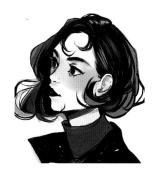

Mental health

Good mental health is beneficial for a working artist. This doesn't mean that you won't feel doubt in yourself or your work. Actually, doubt about your identity as an artist may actually make you more of an artist. By questioning yourself and your work, you ultimately move forward rather than remaining stagnant. You make progress, and that is positive.

From a practical point of view, you may sometimes fail to organize your life in a way that allows you to draw. You might not be able to find the time and then feel guilty or frustrated. Try to figure out if it's something that you need to change or accept. Maybe it's due to a lack of time, too few assignments, or too little success with others. You are not helpless, and it does not mean that you have to blame yourself, but it also doesn't help to dwell on things that are out of your control. Focus on what you can do to get started, without having to wait for others.

Use talent

I was angry for a long time because I never had the opportunity to take a class. But I now know that I can use my time and talent to learn what others were taught in school. People who take a class are encouraged and motivated during their studies, but ultimately also have to search for themselves.

When I see someone else make a perfect anatomical drawing, instead of feeling inferior or unmotivated, I see it as a learning opportunity. If I feel I am not on the same level as the person who has achieved this, then I will actively think about how they did it. This helps me to learn and grow.

People sometimes say that you are lucky if you have talent, but I do not believe that. There are few limitations if you have the drive. You can always build skills and knowledge.

Peace with imperfection

In the past, I found it very difficult to find satisfaction with my own work. I was more likely to become jealous of others, because they were able to do something that I could not. The secret is to turn jealousy into admiration and inspiration, which leads to positive motivation. You can learn from other people by expressing your admiration. This positive approach will be good for you, and you may begin to notice that the other person also has doubts. I try to find peace with my imperfections and I have accepted that I am still learning. There is no such thing as "an artist who has nothing more to learn."

Jealousy is indeed quite common. You do not have to be better than anyone else is, but to get ahead you have to take steps so you're the best you can be. Look critically at what you can improve in your own work and remember that no one is perfect. Do not put yourself down—just get started.

LOOK AT YOUR OWN WORK

Being dissatisfied with your own work is not bad; it is good to look critically, because it means you are looking for ways to improve.
- View a piece or a number of sketches and find points for improvement.
- Try to think about the underlying reason for your flaws. Are your technical skills not sufficiently developed?

Sometimes your eye is better than your hand; you can picture it, but can't execute it properly. You can practice those technical skills (See sample exercises on pages 90-91).

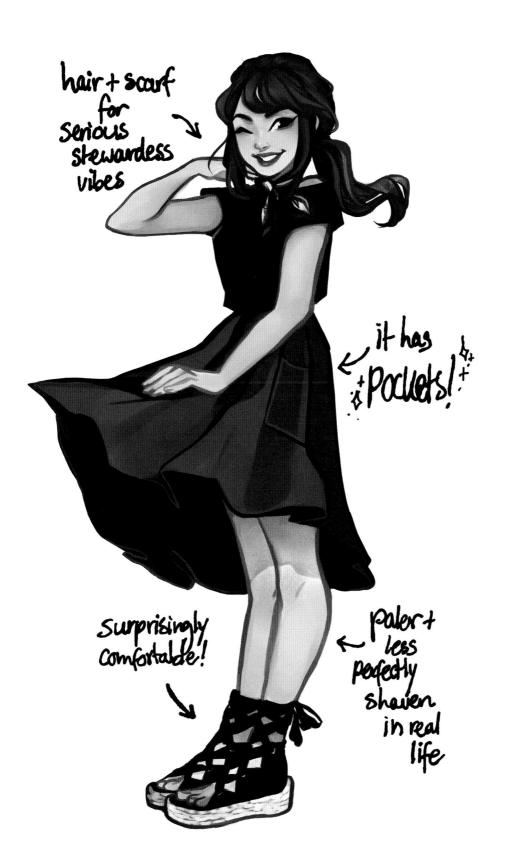

hair + scarf for serious stewardess vibes

it has *Pockets!*

surprisingly comfortable!

paler + less perfectly shaven in real life

Notes to Self:

Not feeling satisfied is
GOOD

feel comfortable being
a student,
cause that's what
you'll be forever

put art in
perspective
when it
consumes
you

let go of what's out of
your control, focus on
what is in your hands

(you're not half as pretentious
as you fear you are so
try not to sound like it
to others, lol)

Consume when you can't Create

Art block

I faced a tough period where I regularly suffered from an art block, barely succeeded at drawing, and didn't improve with my freehand work. I found it difficult to get out of my comfort zone, and I thought my work needed to be innovative and revolutionary. But then I realized I create because I think it's important and that is what matters. I try to listen to myself and not get carried away by the down-to-earth culture in which I grew up. You can be ambitious and be taken seriously, but you should not expect to constantly take gigantic steps forward.

One of the most common causes of an art block is lagging behind in your technical skills in relation to how you look at your work. In other words, you see what can be done better, but you don't know how to make it happen. It's extremely frustrating, but actually a good starting point to improve yourself! When you see your mistakes, then you know which drawing skills to practice.

In the end this is a phase that goes by

Sometimes your work can become your whole world. But the moment it doesn't go well, can be a good learning experience and help you look outside of your obsession. There are so many other things to enjoy. Look at the meaning art has for you and for others. It does not have to be your whole life.

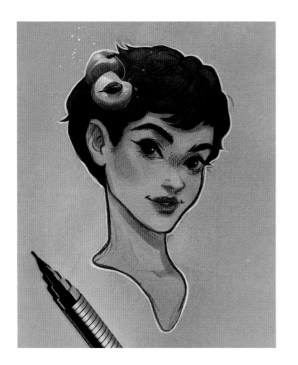

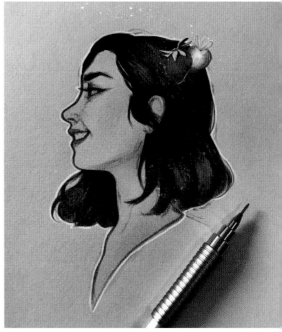

TWO BLUE-HAIRED LADIES

These are examples of small drawings I make to get out of an art block and in my comfort zone. That is how, despite my art block, I can make something without putting too much pressure on myself. If I do not post too often, I'm afraid people will see my work less, but it turns out that most followers don't even notice when I take a little break.

Exercises to lift spirits

The causes of art block can be very different. You want to continue but are unable to renew your excitement. You get insufficient (or too many) likes or assignments. Do you doubt your drawing skills? It helps me to work by commission for a time, or on fan art (see exercise on page 29). Drawing what other people want to see is a relatively easy and guilt-free way to stay busy and ensure that you do not come to a complete stop. That way you stay warm and you will not become bored.

TO CONSUME

Consume when you cannot create. Going to films, observing life, and engaging in interesting conversations can help you get out of your art block coma. Why do you think something is good or not? It's a perfect excuse to binge-watch something with someone (or solo)!

ANOTHER FORM OF CREATIVITY

Find another form of creativity to practice. It can be anything—singing, dancing, or something else. I like to photograph myself. A concept artist friend of mine likes to take singing lessons.

Request feedback

Feedback from others is fundamentally how I am able to look at my own work in a new way. I do this with character designs. I give sketches to friends or post them without explanation and let others analyze what they see. This is how you can find out how what is drawn on paper is translated and experienced by others. If I work as a concept artist, I involve test groups in the development of new characters. They must then—without prior information—come up with a story for the figures that I have sketched. I like when my viewers come up with the relationship I was trying to portray between my characters. Sometimes, I get a fresh take on a drawing, that I would not have thought of otherwise.

WORK EXCHANGES

Discuss your own work. Look for like-minded people who share your interests, or who like your work. Exchange pieces with each other. Ask for (constructive) feedback and engage in conversation.

DEMONS LINEUP

If I show this drawing without a story, most people will know that there is a relationship between the two figures on the left and a connection between the two on the right. This is due to shapes, color shades, and fashion choices. to: Although all four individual outfits appear different, there are some similiarities.

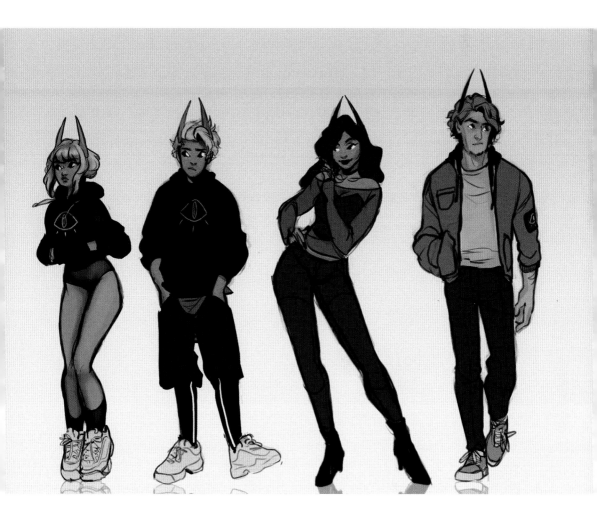

CHALLENGE YOURSELF

Do what you find the most exciting. If you don't try, you never know what you can do. And maybe (mostly!) it is not too bad.
- Choose a drawing that you are proud of, something that you do very well and is clearly in your comfort zone, like characters.
- Choose something you think you will never be able to draw. In my case, that would be a building with a complicated perspective, or animals.
- Make a drawing of the most difficult element.
- Compare the result of the hardest thing you can think of with a drawing you are proud of. In the latter, you probably have already invested a lot of time, but hardly any in the first. Something that seemed very difficult to you turns out to be surprisingly good! Be proud.

MAKE A SELF-PORTRAIT AGAIN

Are you stuck? Do you have a tendency to keep trying, or to throw your tablet or pencil down? With this exercise, you will see what you can do and how your work has improved.
- Take your self-portrait from page 15 (or another drawing from some time ago).
- Consider what you would do differently now. Reflect upon your choices and try to put yourself back in the mindset of your old work. See which elements you want to keep, which you want to change, and whether you can visualize the elements in a better way.
- Recreate the drawing.
- View the differences and see your progression!

You can also do this exercise with other drawings or parts. Practice a part that you are good at, and become even better.

Other important issues

In addition to your work, many other things are important and easy to forget. Consider which topics or themes you follow, what touches you, and what you want to commit to. It can be something personal, something you run into, or a broader social conflict. Making artwork for such a specific purpose, not just concrete inspiration, puts your work into perspective. For example, I once made a mini-comic about autism that was shared online. People recognized themselves in it, which made me feel that I could really help others.

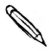

PUT IT IN PERSPECTIVE
- Choose a subject that touches you personally.
- Create a work that deals with this theme.

Done!

It's done! This expedition and this sketchbook end here. I hope the advice that I always give myself and which I have now packaged in this book will help you, too. Have fun drawing!

✱ Keep me posted

Don't forget to post the drawings you have made from the assignments I have given you in this book. Use the hashtag **#expeditionsketchbook** on Instagram and tag **@cyarine**.

Thank you

Thank you!

I would particularly like to thank you as a reader. As an artist, I am nobody without the viewer. My work is a direct expression of my interests and observations, especially because I am someone who does not communicate easily. I feel more heard and appreciated than I ever did. The stories behind my drawings are never deep, and to just me, my work has little value, other than the value you as a viewer can give it.

Thanks also to the team with whom I have been able to make this book and to the people in my area who support me - often more as a person than as an artist.